a brief history

GRETCHEN STRINGER-ROBINSON

Published by The History Press
Charleston, SC 29403
www.historypress.net

Copyright © 2006 by Gretchen Stringer-Robinson
All rights reserved

Cover images: Folly Beach postcards. *Author's collection.*

First published 2006
Second printing 2007
Third printing 2011

Manufactured in the United States
ISBN 978.1.59629.111.9

Library of Congress Cataloging-in-Publication Data

Stringer-Robinson, Gretchen.
Folly Beach : a brief history / Gretchen Stringer-Robinson.
p. cm.
Includes bibliographical references and index.
ISBN 978-1-59629-111-9 (alk. paper)
1. Folly Beach (S.C.)--History. I. Title.
F279.F63S75 2006
975.7'91--dc22
2006001252

Notice: The information in this book is true and complete to the best of our knowledge. It is offered without guarantee on the part of the author or The History Press. The author and The History Press disclaim all liability in connection with the use of this book.

All images are from the author's personal collection unless otherwise noted.

All rights reserved. No part of this book may be reproduced or transmitted in any form whatsoever without prior written permission from the publisher except in the case of brief quotations embodied in critical articles and reviews.

Contents

Acknowledgements	7
Introduction	9
1. Early History	11
2. Civil War	15
3. The Early 1900s to the 1930s	29
4. The 1940s and World War II	35
5. The 1950s	42
6. The 1960s and '70s	49
7. The '80s and Beyond	56
8. People and Places of Folly	59
9. The Pier and Pavilion	77
10. Sharks and Other Folly Wildlife	89
11. Hurricanes	93
12. Surrounding Areas	98
Epilogue	113
Bibliography	117
Index	121
About the Author	127

Acknowledgements

Books are much more of a collaborative effort than most folks realize. It is amazing how people open up and tell you the most interesting (sometimes outrageous) stories when they know you are writing a book. Several people gave me snippets of their family histories, several offered opinions about various events or people; others offered insight into different avenues of research. Some simply gave me the space to do what I needed to do.

Certainly, thanks go to all who talked with me about Folly Beach, and those who talked with me about investigating history itself. Thanks to those who have passed on: Tommy and Kitty Wienges; Jimmy Ballard; and my parents, Ed and Joy Stringer. And to those who are still with us: Wallace Benson, Cliff Benson, Gered Lennon, LaJuan Kennedy, George Gilbert and Marlene Estridge. Others who shared stories are mentioned within the book. Sandra Stringer organized the family photos so well, they were easy to use. Elizabeth Stringer-Nettles helped me with these acknowledgements (it's harder than you think) and as my niece-boss, gave me time off from work to focus on Folly. Also, Rich Bodek at the College of Charleston gave me different research ideas that made my investigation of Folly more interesting.

Undoubtedly, my husband, Ed, gets a big thank you for recognizing Folly Beach as the place where he met the love of his life (that would be me). I also want to thank him for numerous cups of hot tea brought to me while at the keyboard, and his unassuming support. Thank you, Rick, for being my brother and boss and giving me the time off when I needed it, for sharing your memories of Folly as well as your shark lore. Thanks, too, for suggesting I write the book in the first place. Thank you to my brother Eddy for the great shots of the lighthouse; to my sisters, Karen, Jackie, Kathy and Amy for sharing family photos and being my siblings and growing up with me on our little spit of sand. It was pretty cool, huh?

I hope you enjoy reading this book as much as I enjoyed writing it.

Introduction

I have a friend who calls Folly Beach, South Carolina, the "metaphysical center of the universe," although I believe now most people call it "The Edge of America." I rather like the metaphysical slant. I think my friend is praising Folly's clear ocean air and the quirky atmosphere of the small community. I know it is a magical place and, for me, Folly Road is a bit of a mystical highway.

Folly's salt air makes time stand still and the world outside dissolves. If you squint and the sun is just right, the whole planet is blackberry vines and stickers and lawns that have to be coaxed to grow green over centuries of sand. The rest of the world gleans its existence from this small island; the mighty oak in Charleston is just a reflection of the tough scrub on the front beach.

This book is a history of Folly Beach, South Carolina, but it is also a celebration. Folly is a microcosm of America: torn by the Civil War, united by World Wars, now facing developers and entrepreneurs. The people on Folly are just like all Americans, willing to pitch in for a neighbor in trouble and just as willing to "discuss" those troubles freely. They are good, hardworking people who love their homes. They just happen to live on a beautiful island.

The magic of Folly is that once you've lived there you love it. I remember freezing in the winter—renting in the 1970s a house built in the 1930s, when most people only lived on the beach in the summer. There was no insulation, only oil heat. The cold winter air whisked through the house as if all the doors and windows were open.

I love it, Folly Beach. The island has always been the "poor cousin" of Charleston. Charleston, with its harbor and grand antebellum houses and churches, out-classes Folly. The Isle of Palms and Sullivan's Island are residential beaches. People come to Folly to party and leave their trash

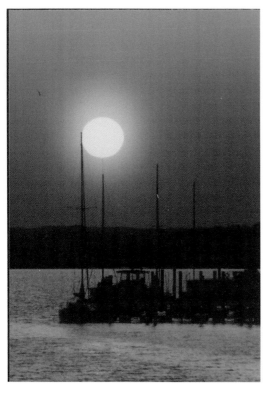
Folly River at sunset, 1980s.

and beer cans on our island. We clean up after them and in the winter, we have the beach to ourselves. Folly has always been a poor man's beach—the Cinderella of the Lowcountry.

The residents know the allure of the island. They love the sand, the echo of the big bands remembered in the wind. It was not that long ago that a Folly resident's check was not accepted in Charleston. Artists, beach bums and bohemian types lived on Folly. Now Folly is becoming upscale and some would say it is losing its personality. I have faith, though. Folly is still eclectic. Yes, professionals live there, driving down Folly Road, Monday through Friday, to their little cubicles. Then, on the weekend, they surf, paint, act. Time, erosion and man cannot harm this tough bunch of sand dunes that have withstood wars and bulldozers, even epidemics and shipwrecks. Long after her sister islands have settled into domestic residential doldrums, Folly Island will be exuberant and lively—the metaphysical center of the universe.

I.
Early History

Folly Island lies about six miles to the south of Charleston. Among the flora that thrive on the beach are cherry laurel, magnolia, cassina, saltwater cedar and, of course, the palmetto and live oak. Running 6.26 miles along the Atlantic, Folly is roughly a half a mile wide. It is cradled by the Atlantic Ocean and the Folly River; therefore, it boasts both beaches and marshlands.

Folly is a beach-ridge barrier island—that is, it was formed by the accretion of sand over hundreds of years. This sand formed ridges, and as the sand accumulated, tidal creeks and marshes formed. Eventually enough sand accumulated in some areas for larger plants to take hold. In fact, Folly still hosts one of the last remaining marine forests, on the east end of the island.

A typical barrier island has marsh or tidal creeks "behind" it and the beach in "front," and is usually longer than it is wide—both are true of Folly. Our island was formed by waves and wind and is directly affected by these elements to this day, no matter what the Army Corps of Engineers and property owners try to do. The tidal flow of Charleston Harbor helped create Folly Beach and still affects the island.

The early settlers of South Carolina found nineteen American Indian tribes inhabiting the islands and inland. Upper South Carolina was inhabited by the Cherokee, the west by the Creeks and the east by the Catawbas. A tribe known as the Kussoe or Cusabo lived in a village near Charleston Harbor. They inhabited the coast and their name meant Coosawhatchie River People. There were about three thousand Cusabo in 1600. Their group was made up of several sub-tribes, the Bohickets, Stonos and Kiawahs. It was probably the Bohickets who lived on Folly. The Kiawah lived on Morris and James Islands. The Stonos lived on the shores

Map from *A Compendium of Field Trips of South Carolina Geology with Emphasis on The Charleston, South Carolina, Area.* Courtesy Gered Lennon.

of the Stono River. Usually the native peoples lived on the islands in the summer and moved inland in the winter. They returned to the same site each summer.

In the late 1600s, various tribes began moving northward in an attempt to avoid English settlers. The Lords Proprietors were claiming more land and the Indians who remained were pushed onto smaller, less desirable lands. An Indian revolt in 1617 led to the gruesome Yamassee War, which destroyed half of South Carolina's Indian population. By the early 1700s there were only eight native settlements left, among which were Kiawah, Seabrook and Wadmalaw.

The word "Folly" is derived from Old English, meaning an area of dense foliage. Old maps of Charleston show quite a few other "follies" as well. Shute's Folly, originally owned by Joseph Shute, is what we now know as Castle Pinckney.

On September 9, 1696, Folly was deeded to William Rivers. The deed describes the property as seven hundred acres in Berkeley County (this portion of Berkeley is now Charleston County), known as Folly Island, to the south of James Island, bound southeast by the sea, west by a creek and northwest by marsh. Rivers in turn deeded the island to his heirs. In 1744, John Stanyarne (Rivers's grandson) sold the island to Henry Samsways.

Mr. Samsways's will refers to Folly Island as Coffin Land, and a map from 1780 names Folly as such; however, a map dated 1800 shows Coffin Land to be a portion of land on the west end of Folly. In any event, the name Coffin Land seems appropriate, as it was customary in the 1800s for ships with plague or cholera victims to leave the ill travelers on barrier islands when approaching a large port. After conducting their business, the captains would then return and pick up the survivors, burying the dead on the island.

In 1832, the *Amelia* wrecked on Folly Island while sailing from New York to New Orleans. Of 120 passengers, 20 died of cholera while marooned on Folly Beach. Charleston, in a panic over a possible epidemic, cut off communications and supplies to the island. A man from the city went to the wreck and upon his return to Charleston was fatally attacked for fear of him bringing the disease to the town. On November 9, 1832, Charlestonians burned the wreck and cargo. A patrol was set up to guard against other diseased visitors from Folly. In 1837 the South Carolina General Assembly allocated a settlement for damages to the victims.

Thomas Gillespie, a Scottish captain, died on Folly on February 3, 1838. A marker was placed at the southeastern end of the island. His stone read as follows:

Beneath
This sad memorial of the sacred love and lasting regret
Of those who have consecrated it to his memory
Lie the remains of Thomas Gillespie, a native of Scotland
Who departed this life on the 3rd of Feb. 1838
In the 54th year of his age
But through mournful dispensation fond friends are
bereft
Of an inestimable companion but their bereaved hearts
Will find again consolatory resources in fondly
cherishing
His precious memory.

Folly Island is not mentioned specifically in reference to the Revolutionary War, although in *The Compact History of the Revolutionary War*, by R. Ernest and Trevor N. Dupuy, it is stated that there were "skirmishes" on the islands near Charleston. James Island is mentioned by name, and it seems likely that Folly would have been a steppingstone to it and thus to Charleston. As in the Civil War, Charleston was under siege. In this war, though, Charleston capitulated to the British. It is interesting to note that our own Fort Johnson fired upon a British ship bringing stamps into Charleston Harbor *ten years* before the Boston Tea Party. Also, Charlestonians seized a tea shipment about the same time as the Boston Tea Party. However, while the Bostonians threw their tea into the harbor, the Charlestonians stored theirs, selling it three years later at auction in order to raise money for the Revolution. While our action may have been more economic, it lacked the flair of the Bostonians'.

It has been suggested that there was a pre–Civil War plantation on Folly with a house, a boat landing, orange trees and rice and indigo crops. There was indeed a plantation on one

of the "follies," or islands, of South Carolina. An old map of Hartford Plantation on the Wando River shows an area of heavy shrubbery marked "folly." There is a deed on record to Archibald Brown giving him the "Cherry Hill tract," which included 124 acres called "The Folly" on French Quarter Creek. There was also a "Folly Landing" on the creek and "Folly Road" leading to the landing, but I don't believe this to be our Folly. Perhaps the "plantation" was actually Union General Quincy Adams Gillmore's headquarters, which were located near the front beach.

2.
CIVIL WAR

The Civil War is a compelling time in history; Northern or Southern, black or white, we are all touched by the gallantry and sacrifice displayed by the people of America in 1860 and the following years. Imagine being a young soldier from New York or Massachusetts stationed on a verdant island in South Carolina in the summer of 1861. Picture the lush growth, the heat, the insects; picture living shoulder to shoulder in a tent with other soldiers, awaiting battle.

In "'It Will Be Many a Day Before Charleston Falls': Letters of a Union Sergeant on Folly Island, August 1863–April 1864," Sergeant Edward King Wightman of the Third New York Volunteer Infantry wrote home on August 6, 1863:

> *We anchored that night in Stono Inlet* [below Folly Island] *and this morning, after traversing a straight* [strait] *as narrow as a canal for two or three miles, brought up at the dock at last and landed on Folly Island. The first thing that attracted my attention was a palmetto tree, reminding me that I am indeed in the heart of the "South."*
>
> *Our camp is in the midst of the sand hills on the beach of the Atlantic, whose roaring breakers I hear tumbling in upon the shore, as I sit here writing. The boys have already caught a crocodile weighing eleven hundred pounds and one of them has been so unlucky as to have his leg bit off by a shark.*

As Sergeant Wightman's letter attests, when Union troops first arrived on Folly, they were greatly taken by the palmetto trees, as well as our sea turtles and alligators. Unfortunately, they also had to deal with our sand fleas, the sand itself and mosquitoes. Several soldiers wrote bitter complaints of sleepless nights and awful, blotchy itches from these pests.

View of a Civil War camp on Folly. *Courtesy Library of Congress.*

Among the other critters that fascinated our Northern visitors were bobcats and oysters. Sergeant Wightman writes of "two thundering big tom cats, scrambling around with their ears tucked back, and their tails the size of your office stove pipe." Later he describes a spontaneous oyster hunt where the men took a small boat and oyster knives (iron hoops) together with pepper and vinegar. Wightman hooked a huge bivalve he described as "Falstaff on the half shell." From the date of his letter, March 1864, it seems the men were smart enough to do their oystering in a month with an *r* in its name.

On August 4, 1863, Sergeant Wightman again writes, "The health of the men is not good here. Almost everyone has either a felon or a couple of boils to amuse himself with. The drinking water is bad and the men bathe too much."

Among the Union soldiers stationed on Folly were the following troops: the Sixth Connecticut, the Third New Hampshire, the Forty-eighth New York, the Seventy-sixth Pennsylvania and the Ninth Maine. Also on Folly at that time were several free black infantry troops, the Fifty-fourth Massachusetts, the Fifty-fifth Massachusetts and the First North Carolina.

Folly Island and Morris Island were strategic locations for the protection of Charleston against invasion by the Federal army. Charleston, with its deep-water harbor and railroad, was a lifeline for communications and supplies for the Confederates. The Union army hoped to overwhelm Folly and Morris Islands, leading to James Island, and finally Charleston. Then Charleston could effectively be cut off from her Confederate sisters.

In *The New Simms History of South Carolina*, Mary Simms states:

> *In the spring of 1863 a fleet of war vessels bringing 13,000 troops appeared off the Charleston Bar. Pine timber piles had been driven in the channels and rope obstructions and torpedoes placed to keep enemy ships out. Northern troops landed secretly on Folly Island where they said the bushes were "thick enough to strip the hide from a rabbit." They began to cut roads and build forts in the woods.*

The Confederate army was entrenched on Morris Island under General John Pemberton and, later, General P.G.T. Beauregard. They flew a palmetto flag given them by the Vincent

family, who owned Morris Island at that time. One stronghold was Battery Wagner, located on the narrowest part of the island and named after Lieutenant Colonel Thomas M. Wagner of the First Regiment of South Carolina Artillery who died at Fort Moultrie. It was made of palmetto logs covered with sand and railroad iron. The fort had guns on the very top and another tier of covered guns to protect the gunners. In addition to all this, it was surrounded by a canal. The Confederates enlarged that battery and ordered more heavy guns on both the channel side and land side of the island. On the tip of Morris Island farthest from Folly stood the Confederate Battery Gregg.

The Rebel commander Warren Ripley had less than two thousand men in Charleston while Union General Alexander Schimmelfennig had six thousand on Folly and eight thousand men at Port Royal and Hilton Head. Later there were Union batteries on both ends of Folly Island that consisted of five to ten thousand men under Brigadier General I. Vodges. In addition to the batteries, General Vodges had a ten-foot wide military road connecting all parts of the island together with two federal gunboats and a mortar schooner in the Stono Inlet and Folly River. The military road was the first road on Folly, although it no longer exists.

The Union soldiers reached Folly by pontoon bridges and began clearing great areas of the island, leaving the outer brush as cover. Their parade grounds were orderly and row after row of tents covered the sands. Like the natives, they camped on the oceanfront in the summer and moved inland on Folly in the winter. With so many men crammed in together and with the multitudes of insects, disease was more fatal than battle on Folly.

The tedium of waiting for battle must have been overwhelming. Sergeant Wightman speaks of the daily routine being on "picket duty or fatigue duty." Sergeant Wightman describes one such picket duty when "four big whale boats transported us from the northern side of Folly Island [Morris Island] through a meandering swampy inlet to Black Island, between Folly and James…[where] we found a detail of the 117th N.Y. camped and relieved them." He goes on to describe the "splinter proofs" the soldiers had built to dodge into when being shot at. These makeshift bomb shelters were "something like a potato house": a long hole about six feet deep, covered with heavy logs, on top of which sand bags were piled. The soldiers would dash into the narrow opening to avoid fragments. Wightman's first picket duty was in a pine tree in which a platform had been built. He had a "splendid view of Sumter, Gregg, Wagner, Johnston, Moultrie, of the rebel works on James Island and of our own batteries." Fatigue duty consisted of leveling camp streets and keeping the parade ground clear. This included digging out stumps. The men lived on "ten hard crackers and two cups of coffee per diem." In a letter dated March 27, 1864, Wightman comments that they finally have more leisure, as "the crazy commander of the detachment [has] leveled down all the sand hills in the neighborhood, [and] now rests from his labors."

According to Katherine Drayton Simons in *Stories of Charleston Harbor*, the first shots of the Civil War were in fact fired by Citadel cadets off of Morris Island. They were shooting at *The Star of the West*, a steamer taking supplies to Major Robert Anderson at Fort Sumter. It was three months later that Beauregard's men fired from Fort Johnson upon Fort Sumter.

FOLLY BEACH

View of a Civil War camp on Folly. *Courtesy Library of Congress.*

The Swamp Angel

At one point, the "Swamp Angel," a Union battery in the marsh on Folly, stood ready to fire upon Charleston. General Gillmore, the Northern commander on Folly Island, had ordered his engineers to build a battery out in the marsh that could shoot more effectively at the city. The engineer lieutenant complained it was impossible, since the marsh mud was sixteen feet deep. His commander answered that he could order anything he wanted, but he was to build the battery. The engineer, his sense of the ludicrous overtaking him, requested one hundred men eighteen feet tall, with permission to splice them if necessary. Apparently the commanding officer did not think the statement funny; he had the lieutenant arrested. The battery was finally built by Colonel Edward Serrell of the New York Volunteers and Lieutenant Peter Mitchie of the Army Corps of Engineers.

The Swamp Angel, so named by a Sergeant Fuller of Company A, New York Volunteer Engineers, was approximately four and a half miles from Charleston and boasted a two-hundred-pound Parrott gun. Its base was a vertical sheet piling protected by grillage and walls of sandbags. The big gun poured shells at Charleston, sixteen of which hit the very center of the city. On its thirty-sixth shot, the gun burst, blowing its own barrel off the carriage. It was replaced by two ten-inch mortars.

Sergeant Wightman, in a letter home on September 14, 1863, writes as a PS:

> *The "Swamp Angel" in the drawing* [which he enclosed in the letter] *originally contained the 200 pounder which fired Charleston. Unluckily it burst. The Rebs don't know it and waste ammunition by the carload to try to silence it. Quite a joke. We laugh a great deal over their plentiful shots, at a deserted underbank. A man occasionally shows himself on the works to keep up the delusion.*

Herman Melville wrote a poem about the Swamp Angel, describing it as an avenger:

> *There is a coal-black Angel*
> *With a thick Afric lip,*
> *And he dwells (like the hunted and harried)*
> *In a swamp where the green frogs dip.*
> *But his face is against a City*
> *Which is over a bay of the sea,*
> *And he breathes with a breath that is blastment,*
> *And dooms by a far decree.*

Melville calls Charleston "the proud City," which calls upon Michael (St. Michael's Church), but Michael has "fled from his tower, to the Angel over the sea."

Another poem, published anonymously in *Harper's Weekly* on December 12, 1863, says the Swamp Angel stands "before the wicked city's traitor hold" and "sends back the hound's deep-throated tone"; it is a "demon still."

Yet another poem, written by W. Gilmore Simms and titled "The Angel of the Church," describes the cannon's attempt to strike St. Michael's:

> *Aye, strike with sacrilegious aim*
> *The Temple of the living God;*
> *Hurl iron bolt and seething flame*
> *Through aisle which holiest feet have trod;*
> *Tear up the altar, spoil the tomb.*
> *And, raging with demonic ire,*
> *Send down, in sudden crash of doom,*
> *That grand, old, sky-sustaining spire.*

Simms's poem focuses more on St. Michael's, referencing (very poetically) the biblical allusions to the church's namesake, and negatively referencing the Swamp Angel's attempts to destroy it.

Obviously the Swamp Angel struck a chord in the imaginations of the times. The writers' views, I am sure, reflected their political beliefs.

The Battle for Morris Island

In April of 1863, the Confederates were given a surprising opportunity. The *Keokuk*, a Federal ironclad, had sunk just off Folly Island after heavy Confederate fire in Charleston Harbor. Although the Union army tried to blow up the ship, they failed. The Confederate soldiers were allowed to plunder it unhindered by the Union soldiers, leading them to believe there were only a few enemy soldiers on Folly, and no new battlements.

While it may seem foolish, the retrieval of the big guns of the *Keokuk* was actually a remarkable accomplishment. There were two eleven-inch Dahlgren smoothbore cannons on the ship.

These guns were thirteen and a half feet long, four feet in diameter and weighed eight tons each. Adolphus W. LaCoste was a top civilian ship-rigger in Charleston and he oversaw the salvage operation of the wreck of the *Keokuk*. The ship was floundering thirteen hundred yards off Morris Island in about eighteen feet of water.

Unknown to the Confederates, the Union blockade fleet stood watch two miles away and, of course, there were Union soldiers on Folly. The men on the salvage team could only work two to two and a half hours a night because of the tides. Often they would be almost washed off of the ship. It was necessary to work in the dark and as silently as possible. First the men chiseled the turrets that held the guns in place using sledgehammers, chisels, wrenches and crowbars. They had to slip under the water to loosen the brass trunnion caps that held the guns in the carriages. Then they used a derrick and lifting tackle to load the guns from the *Keokuk* to their waiting ship. The salvage took three weeks, a couple of hundred men, three ships and several small boats.

When the Confederates finally got the first salvaged gun on the ship to be transported, fifteen hundred sandbags were set on the bow to counter-balance the weight of the cannon. It was only with the help of a very large wave that the men were able to get the gun onto the boat at all. On April 20, 1863, the Union fleet shot at the soldiers as they rowed out to the *Keokuk*. The Confederate gunboat *Chicora* engaged them and they stopped firing. The *Palmetto State* stood guard with the *Chicora* while the *Etiwan* carried the first gun back to shore.

After the retrieval of the first gun, LaCoste became ill and his brother, James, took his place leading the retrieval efforts. The first Dahlgren was taken to Fort Sumter, then moved to Battery Ramsey at White Point Gardens. It was ultimately destroyed. The second Dahlgren was taken to Battery Bee on Sullivan's Island where the ship carrying it was overturned. The cannon was buried by the sands, but later rediscovered by soldiers stationed at Fort Moultrie. Today it can be seen at the Battery at the corner of East Bay and South Battery Streets.

According to John A. Porter, a Union soldier stationed on Folly in 1863, there was another ruse used in June of 1863 to blind the Confederates to the increasing Federal presence on Folly and planned invasion of Morris Island. He states in an excerpt from *Personal Recollections 1861–1865* that the Federal army allowed certain "papers" to fall into Rebel hands. These papers stated that all the Union troops that could be spared were to be taken from Port Royal and sent to the Gulf. The Federal army made a big show of shipping them off at dusk, and the soldiers landed secretly on Folly Island during the night.

On June 12, 1863, John C. Mitchel of the First South Carolina Artillery on Morris Island fired on Folly. The Union army did not fire back; they were busy building batteries for forty-seven guns and mortars, only one thousand yards away. Several Federal soldiers were killed and wounded by the Confederates. Not receiving answering fire and totally oblivious to the Federal constructions, the Confederate soldiers did not continue their barrage.

The Confederates remained unaware of the Union batteries until July 9, 1863, despite lookout stations on the old lighthouse on Morris Island and on the masthead of the *Ruby*, a wrecked blockade-runner, off Lighthouse Inlet. They were aware, though, of the defensive batteries that were visible from Secessionville.

General Gillmore still had a few more tricks planned to fake out the Confederate troops. First, he planned to land a force on James Island, thereby sidetracking the Rebels and causing them to respond to that attack, leaving Morris Island vulnerable. Union troops could then attack Morris Island easily. Second, he planned to burn the Charleston-Savannah Railroad bridge, thereby cutting communications between the two Southern cities.

Gillmore's troops landed easily on James Island. General Beauregard actually feared that actions toward James Island were a ruse to get Morris Island and did not move his men. Gillmore's attempt to burn the Charleston-Savannah Railroad bridge failed and no troops were moved from Morris Island to respond to that attempt.

By the time of the invasion of Morris Island, the Federal navy also held Stono Inlet and Stono River. The Union forces used the inlet as their base and concentrated a force of 10,000 infantry, 350 artillery and 600 engineer troops for the attack on Morris Island. By the tenth of July, the Union army had 47 guns and mortars plus 1,000 men in reserve, ready to cross the inlet in boats.

The Confederates had about 200 men in two companies and a detachment of the First South Carolina Artillery, an additional 400 men of the Twenty-first South Carolina Volunteers, led by Major G.W. McIver, and a detachment of 50 men from the First South Carolina Infantry under Captain Charles T. Haskell Jr. Battery Wagner, on Morris Island, was garrisoned by two artillery companies, bringing the total up to 927 men. In *The Siege of Charleston*, E. Milby Burton states that the Union troops had a two to one advantage over the Rebel forces as of July 10.

The Union army was ready to attack on July 6, but the movement was postponed. On July 8, Confederate Captain Haskell was scouting from Morris Island and discovered the barges moored in the creek behind Folly Island. However, the Confederates did not consider this a threat.

The Federals prepared to attack on the ninth of July, but bad weather delayed the move again. Just after daybreak on July 10, the batteries from Folly began their barrage on Morris Island. After three hours of bombardment, Union Brigadier General T. Seymour led the land attack. Involved in the attack were the Seventh Connecticut, Sixth Connecticut, Forty-eighth New York, Ninth Maine, Third New Hampshire and Seventy-sixth Pennsylvania. In his recollections, Officer John Porter states that his whole brigade was loaded onto surfboats on the night of July 9. They sailed the nine miles around Morris Island and landed on the back of the island. Just before landing, the soldiers motioned to their hidden batteries to open fire. Distracted by the shots, the Confederates were totally unaware of the landing troops. After the Union troops landed, they sent the boats back for reinforcements. The men had been ordered to leave their supplies in the boats, on the assumption that they could collect them when they returned. However, the boats did not return and the men were stranded three days without any food.

At any rate, the Union army routed the Rebels on the beaches, driving them back to Fort Wagner. Officer Porter stated that he didn't even think one shot had been fired by the Confederates, in part because, with the tide so low, the Rebels could not point their cannons low enough to fire. It seems, also, that the Confederates were taken quite by surprise. When the Federals cleared the makeshift Rebel camp, they found breakfast cooking and coats and

rifles lying about. Union troops took nine batteries in about twenty minutes. (A battery can be a simple sandbag type of protection or better.)

The Union army was now on Morris Island. Their next goal was to take Battery Wagner, which stood roughly thirteen hundred yards from the beach they had taken. The first assault, which began at ten o'clock on July 18, was led by the Seventh Connecticut, followed by the Seventy-sixth Pennsylvania and Ninth Maine. The men of the Seventh Connecticut actually crossed the moat surrounding Wagner and reached the parapet of the battery. There they waited for the two other regiments to reinforce them. However, the supporting troops broke under fire from the Confederates while only two hundred yards from Wagner, leaving the Connecticut troops stranded on the parapets. At roll call the next day, only 88 out of the original 196 of the Seventh Connecticut answered. The Seventy-sixth Pennsylvania suffered 180 casualties; the Ninth Maine, 56. Only 12 Confederates were killed or wounded; the total Union loss was 339. The Confederates were lucky—they had had reinforcements and they were fighting from a protected position while the Union army was scrambling up a beach, under makeshift trenches, under fire from the fort.

Officer Porter recounted the retreat in a haze of exhaustion and hunger, stating that he was finally so disoriented that he casually walked away while under fire during the retreat. When he discovered what he had done, he saw that he had been shot in the trouser leg—the bullet narrowly missing his leg—and that another bullet had landed only an inch away from his ammunition pack.

The second assault on Fort Wagner was on July 18. General Ripley ordered rice casks to be sunk in the sand on Morris Island for the men to hide in and shoot from. These were the precursors of the foxholes of World War I and were called rat holes. By the time of the second assault, Gillmore had forty guns in four batteries set on Morris Island.

The Confederates had thirteen hundred men at Fort Wagner by then, with reinforcement from the Charleston Battalion led by Lieutenant Colonel Palmer C. Gaillard, the Fifty-first North Carolina under Colonel H. McKethan and the Thirty-first North Carolina under Lieutenant Colonel Charles W. Knight as well as South Carolina artillery under Brigadier General William Booth Taliaferro. These additional troops had come under the cover of night.

At ten o'clock on the morning of July 18, the Union troops began the bombardment of Fort Wagner with fifteen large mortars and twenty-five other guns. The Union Commander J.A. Dahlgren moved in with five monitors, five gunboats and the *New Ironsides*. They averaged fourteen shells a minute that day. Commander Taliaferro estimated that nine thousand shells were shot by the Union troops and ships on that day.

A shot from the *New Ironsides* cut the halyard from which the Confederate flag at Fort Wagner hung. The Union soldiers thought the Confederates were surrendering and started cheering wildly. Then a soldier climbed the parapet and held the flag aloft while others hurried about, fixing the flagpole.

Ten hours after initiating the bombardment, General Gillmore ordered the infantry attack on Fort Wagner, with the Fifty-fourth Massachusetts in the lead. The six thousand troops were led by Brigadier General Thomas Seymour. They fought thirteen hundred Rebels, some of

whom had had no sleep for six nights. The heat and lack of air in the bombproofs of the fort caused several men to faint. The attack was to be in waves of brigade after brigade.

At dusk, the firing ceased.

Burton describes the scene in *The Siege of Charleston*:

> *Men were massed in a solid column a mile long down the beach. In the dim light the first assault wave could be seen advancing…By this time the tide was fairly high, and the beach was narrow; some of the men had to walk in water up to their knees. As they advanced, they were met by fire which tore huge holes in their ranks and cut them down like grass. The column reeled but continued onward. Wagner became a mound of fire from which poured a steady stream of shot and shell, making it almost as light as day. In the advance many men fell into the large craters that had been created by the 11- and 15-inch shells from the fleet, and the dead and dying were piled in heaps.*

A few members of the Fifty-fourth Massachusetts made it to the parapet of the fort where they were almost all killed, including their colonel, Robert Shaw. In their retreat, they ran through the oncoming Union forces, disorienting their comrades. Then the second Union brigade was ordered to attack, but the commander refused to move forward for fifteen or twenty minutes, leaving the Fifty-fourth Massachusetts to their fate. Finally, some Union forces were able to gain access to the fort. By then, all but one of the commanding officers of the first brigade had been killed or wounded.

The Union regiments had been ordered to cap their guns and use only their bayonets. In the second brigade, though, the One Hundredth New York did not follow that order. When they reached the ditch in front of Fort Wagner, they became so excited they fired—into the Third New Hampshire and Forty-eighth New York, killing many of their own men.

By then, the fighting inside the fort was hand-to-hand. One of the reasons the Union troops were able to get inside was that the Confederate Thirty-first North Carolina would not leave their rat holes to protect the left side of the fort. Therefore, the fort was virtually unprotected from that side.

The Union order to retreat was sounded. For the troops inside Fort Wagner, though, this meant nothing. They fought until they were all killed, wounded or captured. In this battle, 188 Confederate soldiers died; there were over 1,500 Union casualties.

A Union artillery company had been given orders to let no one retreat. They were drunk and, using their sabers, cut down the retreating troops, especially the blacks. A wounded white man might be allowed to pass unharmed. Finally, the mob of returning soldiers overwhelmed them but not before more casualties occurred.

There are several eyewitness accounts of wounded Union soldiers lying in the surf, unable to move and therefore drowning in the incoming tide. At daybreak the next morning, there were hundreds of corpses mixed with wounded; in some places, they lay three deep. There was a truce ordered to bury the dead and tend to the wounded. Amputations were performed to save the wounded; the limbs from these operations and the dead would be buried on the beach of Morris Island. During the next siege, shells from the canons on both sides would often uncover the remains.

After this defeat General Gillmore erected new batteries and began firing day and night at Fort Wagner. The barrage was continuous, except for daily lunch breaks. The Union soldiers got so good at shooting at the fort that they were able to get the shots to ricochet off the water and hit the center of the fort on calm days. During one day of the siege, a shot exploded in the water, causing a fish to be blown into the lap of a soldier. The poor soldier never got to cook the fish, however, because the next shot killed him instantly.

At that time, there were only five hundred Rebel soldiers in Wagner with about five hundred others in the rat holes surrounding it. Slowly, Gillmore's men moved toward the fort in zigzagging trenches. Often, they hit water when digging; often, too, they uncovered the remains of comrades. Initially, the men reburied the corpses but eventually this became too bothersome and the bodies (and body parts) were used to shore up the walls of the trenches. In order to take the fort, Gillmore's men had to drag huge guns into the trenches with them, some as large as a three-hundred-pound Parrott that took a hundred men to drag through the sand.

In Wagner, the conditions were not much better, with the stench of the dead, huge flies and water contaminated by dead bodies. Because of damaged supply routes, the food was usually half rotten by the time it arrived at the fort. Conditions were so bad, most troops were replaced every three days, although some got stuck there longer.

As the Union army moved forward, they built batteries that fired on Fort Sumter and Fort Moultrie, as well as Fort Wagner. Wagner was disintegrating from the constant bombardment. Eventually, the Union forces were so close to Wagner, the soldiers could hear each other's voices.

In the canal surrounding Wagner, the Confederates had planted small land mines. These really did little harm to the Union troops, although one man stepped on one, which threw him up into the air, tore off all of his clothes and landed him back in the canal with his elbow on another torpedo.

On September 5, Gillmore began another constant barrage against the fort. Beauregard ordered a gradual withdrawal. The Confederates were to blow up the ammunition and guns before leaving the fort, but the explosives set on the guns didn't go off. All but 46 men (out of the total 1,656 at both Gregg and Wagner) were evacuated.

On September 7, when the Union soldiers entered Fort Wagner, they were greeted with dead bodies everywhere, heads, feet with shoes still on and stench.

In *The Siege of Charleston*, Burton states:

> *After 58 days and nights under incredible conditions, subjected to possibly the heaviest artillery fire ever experienced in such a small area, Wagner stood defiant until the end. A small garrison, usually consisting of less than 1,000 men, held off a well-equipped force of 11,000 fighting men armed with some of the heaviest artillery then known.*

Opinions on the campaign ranged from "the most memorable" to the "most fatal and fruitless" endeavor of the war, both stated by Union survivors. A soldier from Georgia stated he wasn't afraid of hell, "It can't touch Wagner."

In his guidebook *Historic Points of Interest in and Around Charleston, S.C.*, John Johnson briefly recounts the battle for Battery Wagner. Johnson, in this "Confederate Re-Union Edition," organizes his information by date, site and historical event. When Wagner was finally evacuated, Johnson states, "No more gallant defense had ever been made." He states that 18,491 "projectiles" were fired against the fort and that it was "the heaviest land and naval fire ever concentrated on so small a site."

The Union army sustained two casualties for every yard gained on Morris Island. Since the island is virtually non-existent now, it hardly seems a worthwhile sacrifice. At the time, however, it was crucial.

One Union survivor of the battle for Morris Island had an interesting story to tell that was totally unrelated to any battle fought in the area. According to Nancy Roberts in *Ghosts of the Carolinas*, Francis M. Moore was stationed on Folly during the Civil War. He wrote that an army soldier named Yokum was ordered to remove any Negroes living on the island to Port Royal prior to an ensuing battle for Charleston. In speaking with an old black woman, Yokum learned of six treasure chests that had supposedly been buried on the island by pirates. These chests had been buried, in fact, right between two old oak trees in her yard. She told the young soldier of how, just before the pirates left, the leader ruthlessly stabbed one of his men, letting the body tumble in on top of the chests.

As he helped the woman and a young child to the boat to take them to Port Royal, Yokum asked, "I suppose the treasure has long since been dug up?" The woman's answer was no. No one would go near the trees—the dead pirate guarded that treasure and, as far as she cared, he could keep it forever.

Shortly before midnight that night, Yokum and a Lieutenant Hatcher left camp carrying shovels and made their way to the two huge oak trees. Spanish moss was laced among the branches of the gnarled old trees. It is easy to picture the full moon and silver stars.

It was a windless night, but as the men began to dig, the tops of the oaks swayed violently. Lightning flashed but no thunder followed. The men continued digging. Lightning flashed again, lingering this time. Suddenly, the men realized they were not alone. In the strange prolonged lightning, the men saw the clear figure of a pirate.

They dropped their shovels and ran.

The next day, the attack on Morris Island began and both men fought bravely. Fifty years later, Yokum retold his story at a veterans' reunion where Mr. Moore recorded it.

On May 11, 1987, relic collectors on Folly Beach contacted the South Carolina Institute of Archeology and Anthropology about some human remains found on a portion of the Seabrook property on west Folly. The development unearthed several Civil War burial sites. Steven Smith, with Sharon Peknel of the SCIAA, met with Mike Roberts (who represented the landowners) and agreed on a thirty-day halt to construction in order for the SCIAA to remove the burials.

All of the bodies except one had been buried with the heads directed toward the west. Two of the burials were so disrupted that it was impossible to tell in which direction they had

Folly Beach

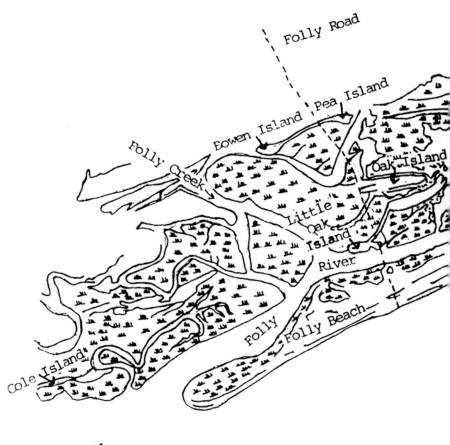

Map of Folly.

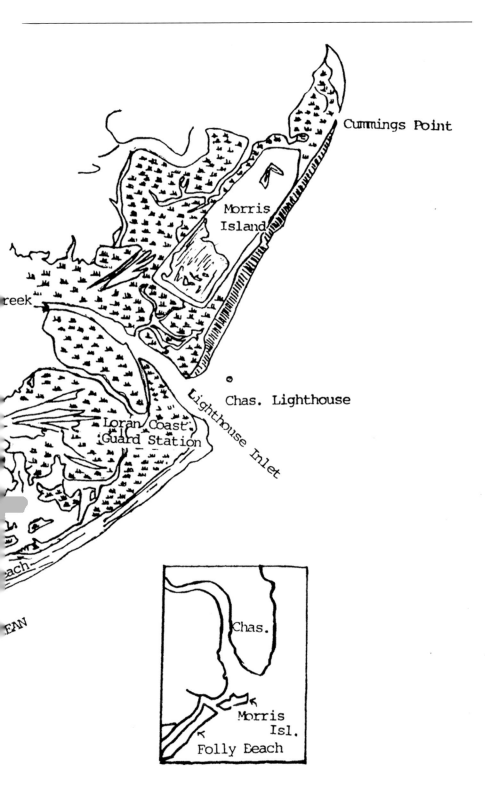

been facing originally. The hands were folded across the midsections of the bodies. A total of fourteen burials were excavated. Of these, only two were complete; the other twelve were missing skulls and other major body sections.

Along with the bodies were found Union army eagle buttons, metal buttons, two .57-caliber Enfield Rifle Minié balls, suspender buckles, rivets, hooks, glasses, a horn and other items. The only insignia found was a "5" from a cap. Some of the burials had coffins; others had only ponchos. Some were a variation of the two.

After much research, the SCIAA concluded that the remains were all of black males from mid-teens to middle age, who apparently died from disease. Battle injuries were detected. At first the SCIAA was unsure if the men were of the Fifty-fourth or Fifty-fifth Massachusetts or the First North Carolina (later the Thirty-fifth U.S.). Finally from the insignias and buttons found it was deduced that they were from the Fifty-fifth Massachusetts Volunteer Infantry Regiment. The men of the Fifty-fifth and Fifty-fourth were free men who signed up for fifty dollars pay and a chance to fight for freedom. Records show that most of the Fifty-fifth were single, with an average age of twenty-three.

There are several (unproven) opinions as to why the majority of the remains were minus skulls. The most probable theory is that bounty hunters sought the skulls of buried Union soldiers when the Federal government offered rewards for the retrieval of bodies. The odd thing about these burials is that, while the skulls were missing, the rest of the bones were undisturbed. Most bounty hunters would not be overly careful when "collecting" their prize. Another unsubstantiated opinion is that the skulls were removed by local islanders for voodoo rituals. While intriguing, that theory really can't be proven.

After the Civil War, Charleston and the surrounding areas set about rebuilding. It is interesting that as early as 1896, Charleston was promoted as a tourist site for Civil War enthusiasts.

3.
THE EARLY 1900S TO THE 1930S

With the end of the Civil War, Folly stepped back into the background of the nation. In the early 1900s Folly was a "tent" city, its homes made mostly of tents or condemned railroad boxcars.

The steamer *Ataquin* carried visitors back and forth from the island. Later, a road was cleared and the popular phrase of the day was "Be independent, make your own rut." You can well imagine the condition of the road during hurricane season. Even a regular high tide could wash saltwater on it. Most of Folly Road was (and still is) poorly lit once past James Island. At one time there was a dangerous curve in the road near Secessionville. Several people were killed there before the road was widened and somewhat straightened in the early 1960s. During World War I it often took two hours on the single-lane road to get to Folly from downtown Charleston. Once on the island, visitors were greeted with goats, bugs, woods and a shanty or two beside the ocean.

J. Douglas Donahue, in the April 13, 1987 *News and Courier*, wrote a useful, entertaining article on the old Folly Road. He says the first landmark on James Island was a roadhouse called the Magic Lantern. Next was Tommy Welch's Pure Oil Service Station and, farther down, Coker's Store at Folly and Camp Road. At the northeast corner of Secessionville Road and Folly Road sat the Folly Road Pantry. Folly Road was owned by Citizens and Southern Bank and was paved in 1936.

Of course, all of the bridges were wooden. Peas Island and Bowens Island had a few shacks; there was a seafood restaurant on Peas Island in World War II, which was supposedly rather primitive and quite popular. About this time, the Tompson Transfer Co. ran busses to Folly. These were on truck chassis with built-in steam systems up front. According to an article in the *Folly Beachcomber*, the bus had two seating levels, with a tasseled shade on top. There were no

telephones on the island, so people depended on the bus line to communicate with the outside world. Each trip, the driver would stop by the drug store and pick up some medicine or some groceries that he would bring to the island residents. He was known by everyone along the road, as well as by the city folk, because when they got stuck on the beach in their cars, the bus would pull them out. The driver carried a towrope at all times.

A wooden bridge and tollgate were erected with a toll of twenty cents per person or fifty cents for a carload. Of course, friends would fill up their cars with passengers to avoid the exorbitant fee. Residents paid three dollars a month and could come and go as often as they liked. Sam Harper, Cliff Wienges and Tommy Wienges collected the tolls and the fees went to the Folly Roadway Company. Typical of Folly, the booth was the subject of ribald songs and limericks, though I couldn't find any copies of these. People even threw things at it.

At that time, goats were used to keep the grass on Folly under control. A popular pastime of the day was "kid-snatching"—trying to sneak a goat past the tollgate and off the island. What one did with a kid in the city, we can only guess.

Most people think the tollgate was located at the building near Sol Legare Road that has been known as various things, including Williams Store, the Toll Gate, Cherokee Woodwork and Barrier Island. Actually, the original gate was five hundred feet closer to Folly, on the right side of Folly Road as you head toward the beach. There is no hint of the original structure at this time.

George Gilbert actually remembers the tollgate. His family stayed on Folly in the summer. He remembers driving to Folly and folding the rumble seat down to hide girlfriends, thereby avoiding the additional fee. He also remembers that the house his family owned on Center Street was quite secluded. The east side of Center was wooded in the 1920s. As a young boy, George and his friends would spend the day on the beach, come home for a sandwich and hit the beach again. They caught the goats that were kept on the island, as little boys would be compelled to do. Later, when he was sixteen, his father gave him a car and he sped up and down the beachfront with friends clinging to the running boards. To his recollection, he hit eighty miles per hour and the beach was wide enough for two-way traffic and parking.

In the early 1930s, there were the remains of another street on Folly, one that is now well under the Atlantic Ocean. Funny, but when someone says there was another street there, we all likely picture a paved lane with storybook houses. However, this old road was only a dirt road (as were all the roads on Folly at that time) and by the late 1930s, there were only three or four houses on it. People knew it was eroding and did not build there. The only home remaining where the road ran was the Atlantic House, which was destroyed in Hurricane Hugo.

So, as early as 1937, erosion was a problem for the beach and was the subject of many commissioners' meetings. Morris Island has lost over sixteen hundred feet of shoreline to erosion since 1939.

During those early years, Center Street was only an oyster-shell path that had the Rooke Home Supply Co. and Shorty's Grill. Center Street was one of the first streets of Folly to be paved, but the sidewalks on Center Street were wooden until the 1940s. All the buildings had false or scrolled fronts with two-by-four supports, so that Center Street looked like a movie lot.

Tall Tales Bait House on Folly Road, mid-1960s. *Stringer family collection.*

In a 1960 issue of the *Folly Beachcomber*, Toby Hernandez tells her story of the early days on Folly:

In 1932 my family came to live on Folly Beach. At this time, there were 9 families here, including mine, living the year round. The Newspaper was delivered by a Chas. Post Office employee and each of us had to get our paper from his house. Mr. Spradling was our one-man fire dept., ice man and general care taker at the Island. He also ran a very small restaurant where a wood stove burned and the fellows gathered to chew the fat. Mr. Rabin had the general store and post office. Hand pumps were used to get water and for the most part the water was red or rust colored so all drinking water had to be carried in jugs from Chas. Electricity was not so convenient and there were times we burned oil lamps...We sweated out 3 major hurricanes. The 1939 storm was the most dangerous as practically all of Folly was under water. The river and ocean came to within 1 block of meeting and on Center St., water was waist high in the lower rooms of my home...I saw, during this storm, houses topple

Folly's dirt roads, 1930s. *Stringer family collection.*

THE EARLY 1900S TO THE 1930S

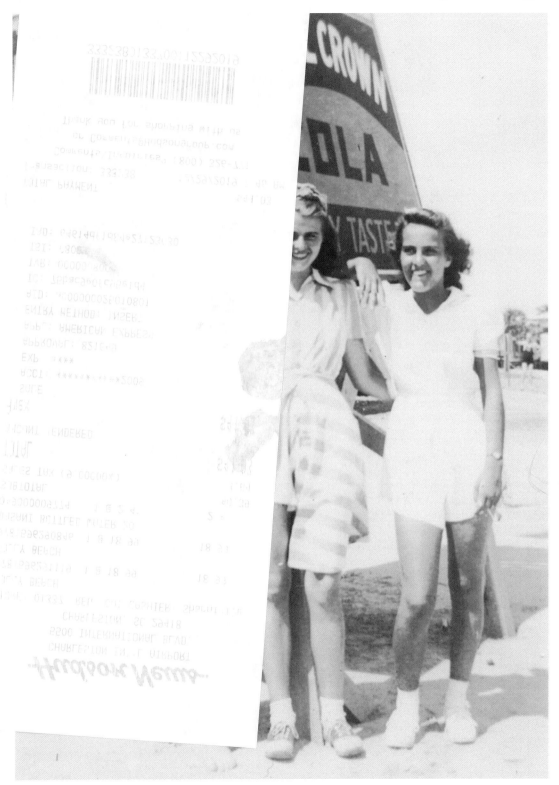

Front beach, by the lifeguard stand, late 1930s. *Stringer family collection.*

into the raging surf and furniture, linen, etc. floating to sea. I also remember when Ashley Ave. was being cut through. I saw the first tree fall. My daughter and I helped pile the brush.

In the early 1900s to 1930, Folly was under the jurisdiction of Charleston County. In the early 1930s, a group of men started discussing the government of Folly while standing outside of the Garden Club and Civic Club one day. From that discussion, in 1936, Folly became a township. The first Board of Township Commissioners consisted of John McDonough, chairman; Sims McDowell; a Mr. Thornhill; A. Seres; and a Mr. Ellsworth; with L. Mendel Rivers as attorney and clerk.

Our first fire truck was towed to the island in the 1930s and had to be almost completely overhauled. It was kept in the garage behind Mazo's Grocery because David Mazo owned the only garage on Folly at the time. Unfortunately, when the first fire broke out, Mr. Mazo was in Charleston on business—with the key to the garage.

There were rumors of bootlegging on the island. Various people and clubs were charged, but no one was ever prosecuted. Gossip was rife as to who was guilty.

Lee Hunt was the first police chief for Folly after the commission government was initiated (Chief Young was police chief when the County ran Folly.) Chief Hunt was both chief of police and building inspector. He was a tall, robust man, quite outspoken. At that time, the jail on Folly consisted of a mere cage in the marsh where the Sandbar Restaurant is now. Any man arrested for drunken or disorderly conduct was locked away with the mosquitoes and heat, and left to sober up for a few days under awful conditions. The jail was later moved to the Civic Club at Center Street; it was also once by the bowling alley on the corner of Center and Arctic Streets with the fire engine in back and the police station in front.

4.
The 1940s and World War II

The 1940s brought great changes to Folly. Coupled with World War II, this era saw an increase in population and, therefore, an increase in housing on the island. Improvements were made to the roads and utilities because of the influx of service people and their families who came to the Charleston area. The bus service, which initially ran only in the summer, was expanded to meet the needs of the increased number of Folly residents.

In the 1940s, the Goss brothers ran a roller skating rink, which was one of the largest in the South and which sat on Center Street and Atlantic Avenue. The Pure Oil Station, run by E.H. Hagan, stood on Center Street, together with Marcus Pharmacy (which was the first drug store on Folly). Thanks to efforts by the Civic Club and its president, Harry Beckmann Jr., on June 9, 1943, the toll on Folly Road was lifted, and the road was made public.

In 1942 Folly initiated its air raid system. The siren sounded at noon on Saturdays until the late 1990s. Folly Beach had seventy-five dollars allotted for this project; the power company donated the poles and ten dollars.

The commission government continued to function. In 1940, Mrs. William R. Secker was city clerk. The marshal (police chief), Lee B. Hunt, was paid $187.50 a month plus a gas allowance of $50.00. Things were not always peaceful on Folly, though. The following is an excerpt from the minutes of a commissioners' meeting on August 31, 1943:

> *It was brought out that Mr. Hunt and Mr. Clark had entered into an argument on Center Street, in front of the Surfside, which culminated in the men threatening to use a gun on the other. Mr. Hunt, who was off duty at the time and not in uniform went home for a gun; returning with the gun, came up Center Street as far as the police and fire station, where he*

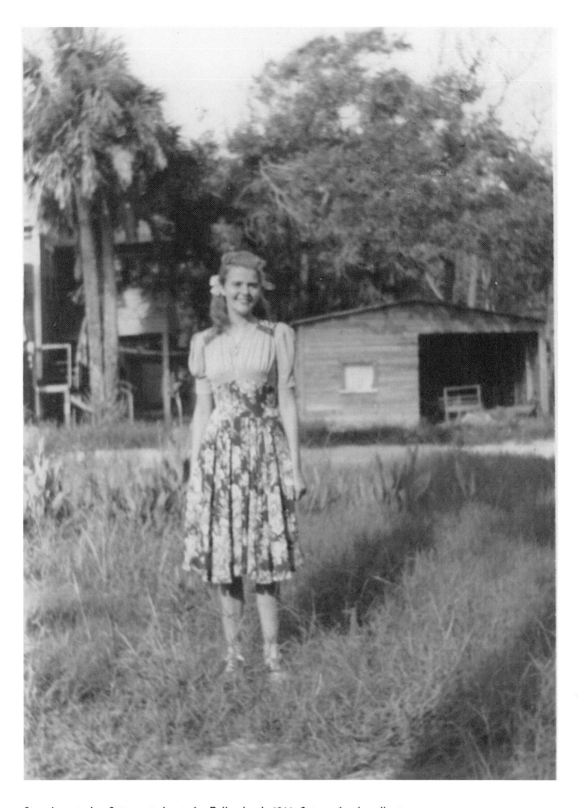

Seen here is Joy Stringer in front of a Folly shack, 1941. *Stringer family collection.*

was surrounded by several men, and the gun [was] taken from him by Lt. John McDonough. At this time, Mr. Clark was in the street by the pavilion, waiting for him. As both were policemen, they were asked to turn in whatever police equipment they had to the township. County Police stepped in for a while.

The cause of the argument is unknown, but my mother, Joy Stringer, told me of watching the "High Noon" adventure from upstairs at McNally's as the two men paced toward each other with guns in their hands. Remember, Center Street was unpaved, the sidewalks were wooden and the storefronts were all false, so the scene resembled something right out of a Western.

That same year, Folly bought a horse and wagon for $150, apparently for garbage collection. In 1944, the speed limit was cut to ten miles per hour on the front beach and on Center Street. It remained twelve miles per hour on the other streets. It was made illegal for any vehicle to be driven or parked on the front beach west of the pier. Also in 1944 Folly changed from a five-man commission to a three-man commission.

The telephone company made a technical survey of Folly Island to establish a dial exchange on the island in August of 1946. Jimmy Ballard stated the first exchange as "Juniper." Later, there would be two pay telephone booths on Folly Beach, one at Ashley and Ninth Street East and one at Ashley and Sixth Street West.

Folly bought a new fire engine in 1946. The Township entered into a contract with International Harvester Company for a one-and-a-half-ton International Truck and another contract with Howe Fire Apparatus Company to build and furnish one Howe Fire Booster Engine.

By 1948, there were streetlights at Cooper and Twelfth Street East, Erie at Third and Fifth East, and Hudson at Second East.

For Americans, World War II began December 7, 1941. Each community has its own collective memory of the war. On Folly, people remember that everyone blacked out the top halves of their automobile lights to cut down on the reflections in case enemy submarines were in the waters. They also had to keep black or dark green shades pulled down in their homes every evening, for the same reason. There was also a curfew on and off throughout the war. When people did travel, they car-pooled to save gasoline.

People came from all over the country to work at the Charleston Navy Yard and workers got special rental rates, due to special government requests. The houses on Folly had been built for summer residence only, but servicemen and navy yard workers were forced to take what they could get. Often the tenants could look outside through cracks in the walls and ceilings (a few still can). It made for an uncomfortable winter. Among the folks who moved here in order to work at the yard where Herman and Dorothy Sealey. Dot Sealey was the librarian on Folly for many years.

There were so many rowdy servicemen on the island during the war, Folly's small police force could not control them, so they requested the service keep them in line. Residents even requested a separate jail for the servicemen. Apparently they got pretty wild. It seems that whether or not they started out on Folly, they ended up here, causing

Township Commissioners of Folly Island, South Carolina, is endebted to Charles E. Baker of Roanoke, Virginia, in the sum of Seven Hundred, Sixty-Six and 25/100 ($766.25) Dollars, for which he holds its fifteen promissory notes in the sum of Fifty-One and 08/100 ($51.08) Dollars each; one of which said notes is payable on the first of each calendar month hereinafter ensuing with interest on each of the said notes from the date thereof at six (6%) percent per annum and to secure the payment of which the said Board of Township Commissioners of Folly Island, South Carolina, do hereby convey to Charles E. Baker the following article of personal property, to wit, one 1941 three-quarter ton Ford fire truck, especially constructed for the use of Folly Beach and bearing No. 6649354

But on this special trust that if the said Board of Township Commissioners of Folly Island, South Carolina, fail to pay the said debt or interest or any installment thereof when due, then in that event, the said Charles E. Baker may seize and sell said property, or so much thereof as may be necessary, by Public Auction for cash, first giving ten days notice, in writing, on the Court House door, and apply the proceeds of such sale to the expenses of the seizure and sale, and then to to the discharge of said debt and interest on the same, and pay any surplus to me.

Given under my Hand and Seal, this 31 day of Dec, A. D. 1941.

WITNESS:

Note for fire truck, 1941. *Stringer family collection.*

problems for the residents. An excerpt from the minutes of the commissioners' meeting on July 5, 1946, reads:

> *The matter of taxis bringing drunk and disorderly persons to the beach was brought up by the chairman and discussed by commission which reached the conclusion there were no steps which could be taken to prohibit the taxis from bringing such persons to the beach.*

In World War II, Fort Johnson on James Island was a receiving station; from there the men of the Folly Beach Mounted Patrol went to Hilton Head and Mounted Beach Patrol School. Finally, they would be assigned to the coast guard station on the east end of Folly.

The horse patrol watched the beachfront all day and night and it took four hours for each man to complete his allotted route. Obviously, they used horses rather than cars to save on gas and to cut down on stray light that might alert subs. The men could not smoke when on duty, for fear that a flare from a match or spark from a cigarette would be seen by an enemy sub.

My father, Ed Stringer, was a member of the Folly Beach Mounted Patrol. He met Joy McDonough on Folly Beach and they got married on March 1, 1944. In 1989, when I spoke with him, he said a typical day on patrol went like this:

> *We'd ride the horses for four-hour shifts, twenty-four hours a day. Two men from the east side of Folly Beach and two men from the west. We'd meet at Center Street and then we'd go and get a beer. We'd go to McNally's, tie our horses up in the back yard, put our submachine guns in the closet and go in the back. It was monotonous. You remember the funny things. Like, we'd ride in the rain, sometimes. You'd go to sleep on the horse and the horse would turn around and you'd be back in the barn, standing in the stall. The horse didn't like that rain! I went to sleep one time, dreamed I was riding in the back of a truck, and fell off the horse. Another guy got a fractured skull riding under the pavilion. He didn't duck! He had a helmet on. Thank God. He could've killed himself. My horse's name was Sis. She raced after a while, but I got transferred before she did. I went overseas and they did away with the horse patrol while I was overseas.*

Only on Folly would it be considered normal to put submachine guns in the closet and have a beer.

Another familiar sight on Folly during World War II was Jack McDonough buzzing Center Street in his B-24 bomber. I spoke with Joy Stringer, my mother and Jack's sister, in 1989 and she said:

> *The first time he did it, [Ed] got a lamp and sent Morse code as Jack was coming down Center Street, wagging his wings. They were lost, really, and his navigator told him he was over Myrtle Beach, but Jack recognized Folly. Once he found the island, he buzzed it pretty often. They would be worried that they'd run out of gas, but they always made it. Everybody on the beach knew it was him.*

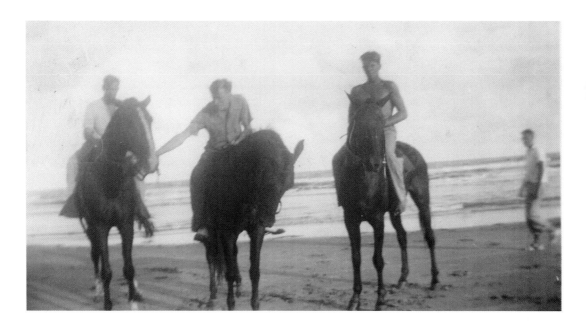

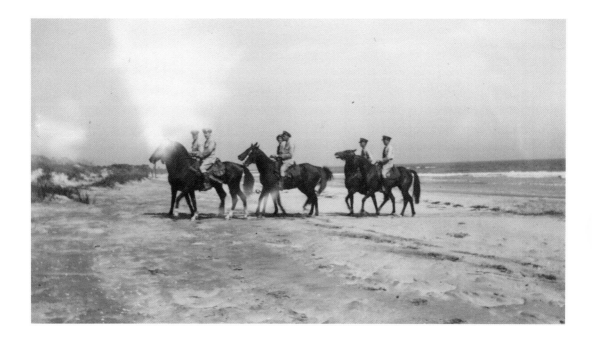

The Folly Beach Mounted Patrol, mid-1940s. *Stringer family collection.*

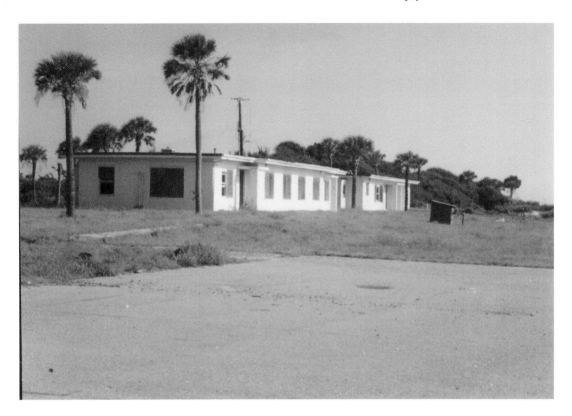

Abandoned coast guard barracks, ca. 1960s.

One telephone connected Folly to Savannah so that reports could be made on submarine sightings. There was no need to dial; it was an automatic connection. One resident, a Mrs. Knutson, reported a sub but this was never authenticated. However, Erma Leckie remembered that two subs were positively sighted and boats were definitely offshore, as debris would float up on the sand.

During the war, the building known as the Atlantic House was watched carefully. A deserted home, it was suspected as a signal post for German spies. This suspicion was never proven.

5.
THE 1950S

The 1950s on Folly continued to bring change and improvement, most notably to its streets and city facilities. A big improvement was the development of a water system on the island. Our police force and fire department expanded and we became a township. The move to incorporate as a city began in the fifties, but was postponed until the seventies. Being Folly, of course, the fifties also included some quirky discoveries and a criminal.

On January 1, 1950, street signs were purchased and placed. I'm not sure if these were the first street signs for Folly, but I know at one time that these signs were wooden because I used to have one. By 1953, most of Folly's streets were paved. That was that same year that the traffic light at Center Street and Arctic was first considered.

There were parking meters along Center Street, I imagine for the additional income to the city. They were purchased from the Dual Parking Meter Company in 1953. Each spring they'd be reinstalled in preparation for the summer influx of visitors, and every fall they were dismantled. I'm not sure when the city stopped setting up the parking meters, but since I actually remember them, they must have been functional in the sixties.

In July of 1956 Arctic Street East was made one-way east from Center Street to Twelfth Street East. Apparently, sand was accumulating across the street and made driving dangerous with parked cars on both sides. The City of Charleston gave Folly Township twelve one-way signs and twelve arrows.

That same year the wooden Folly River Bridge was demolished and a concrete one rebuilt, as were all the bridges on Folly Road. It had been reported in the *News and Courier* that a cement truck fell through the wooden bridge. I don't know if the driver was harmed, but of course the bridge had to be repaired. Apparently it was decided to rebuild using concrete. Mr. J.B. Leseman and Mr. T. Allen Legare, chairman and vice-chairman, respectively, of the old

THE 1950S

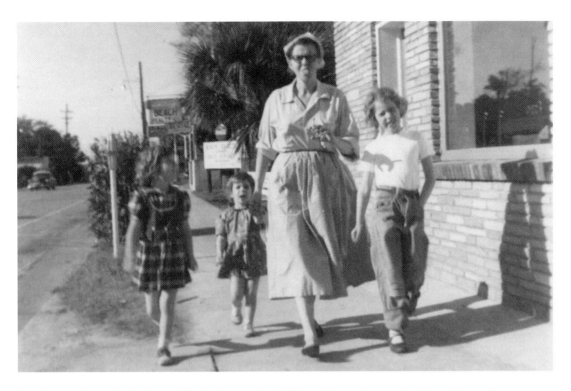

Joy Stringer (center) Jackie and Kathy Stringer (on left) and Karen Stringer (right) on Center Street, in front of the post office, in the mid-1950s. *Stringer family collection.*

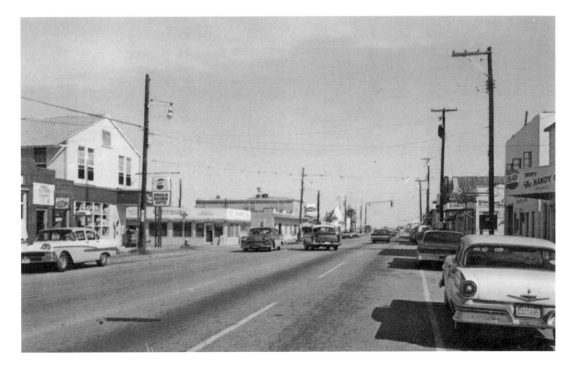

Center Street, ca. 1950s. *Courtesy Karen Stringer.*

View from Little Oak Island (Mariner's Cay) with "old" Folly Bridge in the background, 1930. *Stringer family collection.*

Sanitary and Drainage Commission of Charleston County, worked with the state highway department to improve our roads and bridges. The Folly Beach bridge is now officially named the Lee Westbury Bridge, although most people still just call it the Folly River Bridge or the Folly Beach Bridge like they always did.

Our public safety departments continued to grow in the 1950s. In August of 1950, D.W. Crawford was assistant marshal with a pay of $20.00 over the weekend or $10.00 per day; Marshall Strickland was also on duty in the 1950s. In 1951, Ellis E. Leckie was employed as special police officer in the summer over weekends, with payment described in the commission minutes as "the same rate as last summer, $7.50 per day." In 1953, Folly bought a new police car from the Paul Motor Co. We paid $2,069.93 for it.

On April 15, 1951, an advertisement was run in Charleston papers for bids on a police and fire station building. The bid from Paschal A. Michel for $7,791.87 was approved by the commissioners. Palmetto logs were used for the foundation, to absorb moisture. Our volunteer fire department was created on March 11, 1954, and by February 1955, the new fire engine building was almost complete. On January 9, 1954, William J. Davids, Henry E. Shuler, James Hitopoulos, Thomas A. Jamison and Joe Flood were elected as the Board of Fire Masters. In July of 1959, the Halsy Boat Co. gave the Folly Beach Rescue Squad a new fifteen-foot boat for its rescue operations.

By a petition filed with the secretary of state in July 1951, Folly Beach became a town. We still had a commission-based form of government, though. On January 1, 1953, the Folly Beach Township

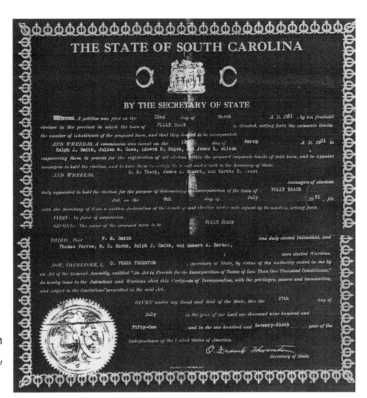

Certificate of Incorporation from Secretary of State, dated July 9, 1951. *Stringer family collection.*

commissioners were Mr. Otis R. Conklin, Mr. Harry Beckmann Jr. and Earl R. Johnson, with Mr. Johnson as chairman. In 1955, A. Baron Holmes III was the city attorney; he was paid a hefty retainer—twenty-five dollars. On December 19, 1956, George Goehring, James Stuart and Lester Stringer were commissioners, with Mr. Stringer acting as chairman. Dr. Anthony Pappas was named township health officer. His salary was one dollar per year!

In addition to these governmental improvements, Folly Beach became a bird sanctuary as a result of a request by H.A. Aimar in 1953.

In 1956, about 200 feet off of East Ashley, in the canal by the river, a wooden ship was unearthed. Its timbers were made of oak and cedar joined with square bronze nails. The bottom was covered with hammered copper and copper nails. It was estimated to be 150 feet long. The find occurred on the property of A.G. Kettas. I was unable to locate any new information about the ship, but talk was that it was from the Civil War. That is entirely possible. I prefer to think it was a pirate ship. Why not?

In his 1957 *Charleston, South Carolina, a Complete Guide—With Maps*, T.J.L. Crane mentions Folly briefly as a "popular summer playground resort with amusement center, bath houses, pavilion, concessions and township facilities." His guidebook says more about Sullivan's Island and Edisto Beach than Folly—reflective of Charleston's 1950s impression of Folly: a good place to take the kids for a romp on the beach, but you probably wouldn't want to live there, even with our civic improvements. Especially since sometimes unsavory folk decided to hide out on the beach.

In 1955, Sue and John Myles Danner unknowingly rented a cottage to Elmer "Trigger" Burke, a professional hit man. Burke had escaped from a Boston prison in 1954 after being jailed for illegal possession of a submachine gun. Police believed it to be the gun used to kill Joseph J. "Specs" O'Keefe, who was involved in a $1.2 million robbery of the Brinks Company.

Mrs. Danner met Burke through an acquaintance who had previously rented from her. She felt sorry for Burke because he was thin and pale. He told her he'd been ill, although his paleness was in fact caused by his incarceration. Burke rented 109 Erie Avenue for two weeks before the FBI arrested him at the corner of Erie and Center Street. They found two .38 pistols and two .22 rifles in his cabin. Burke was sent to New York where he was found guilty of murder in 1958 and sentenced to the electric chair.

Mrs. Danner taught most of Folly Beach to play piano. She never lost her temper even when it was obvious a child's mind wasn't on her studies. I know that from firsthand experience. She was a kind and gracious lady.

Water on Folly

You walk into the kitchen, turn the tap and clean water sparkles into your glass. We bathe, wash laundry and water the lawn automatically; we expect the water to flow into our homes. However, prior to 1957, Folly residents were painfully aware of every cup of water they used. Wells on Folly produced only brackish, dirty brown water unfit for drinking. Folly residents brought their water from Charleston in large containers or bought it from one of the two water carts on Center Street for five cents a gallon. (Jimmy Ballard spoke of a young police officer who thought he had captured a moon-shiner when he stopped our former post master with a couple of gallons of water in the back seat of his car.) The effort to bring water to Folly involved many people and took quite some time.

In December of 1949, the Reconstruction Finance Corporation approved a loan of $192,000 at 4 percent interest (subject to certain regulations) for a water system on Folly. Then, in April 1950, the commissioners decided the Town of Folly would put down the wells for the waterworks and J. Andreas "Peanuts" Wagner was authorized to purchase the necessary equipment for that work. By August of that year, a field of six wells was completed. Unfortunately, these wells did not produce clear water.

The commission had hired John McCrady as engineer for the waterworks but he had not completed the necessary revised plans as of October 11, 1950. Therefore, on November 10, 1950, the commissioners terminated the contract with McCrady and hired Pete Barber and his firm.

The commission records state:

> On September 17, 1953, a special meeting was held to consider requesting the delegation to authorize the issuance of $30,000.00 in general obligation bonds to supplement the funds from the R.F.C. for the purpose of constructing a Waterworks on Folly Island. [It was also resolved] to purchase from Edward M. Seabrook those lots, pieces or parcels of land on Folly Island, S.C.,

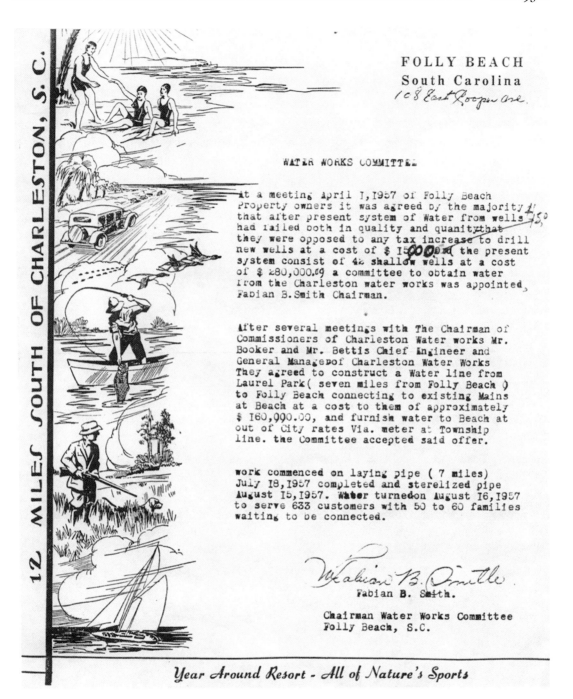

Letter concerning Folly's waterworks, 1957. *Stringer family collection.*

shown as lots 504 and 505 Erie Avenue East on a plat of Folly Island made by the Jefferson Construction Co. in 1920.

Pipes were run from the City of Charleston and by June 9, 1954, the water tanks were being filled; the water was tested. More than half of the homes on the island were connected to the system. The steel tank was delivered and construction of the tower was set to begin. This same tower stood until just a few years ago, when it collapsed. It was rebuilt in 2005.

Mrs. Secker was chosen as bookkeeper and office manager for the waterworks system at a salary of fifty dollars a week. Mrs. Gregg took over the duties of the water department on January 1, 1957; Mrs. Secker retired December 31, 1956.

The members of the first waterworks committee were Lester E. Stringer, Fabian B. Smith, George A. Goehring, James A. Stuart and Curtis H. Winningham.

In mid-August of 1957, Folly's water system was connected into that of the city. Approximately 633 families immediately began receiving water. The local water department was unable to handle the volume, so the Folly water department merged with the City of Charleston's water department. In the early days, with summer visitors to the beach and the fact that the water system was completed during a drought, water had to be rationed and was turned off completely from 9:00 p.m. until 6:00 a.m. each day.

The new water system was funded partially by the sale of water and general obligation bonds. There was additional expense when Folly joined Charleston's water system. Also, once hooked into Charleston's water, roads had to be dug up to lay pipe; these were re-paved, and roads that were not paved when the initial estimates were made also had to be paved. Therefore, the costs of Folly's water system were much higher than at first estimated. Because of these and other unanticipated costs, water rates were raised in an effort to increase the revenues sufficiently to satisfy the bondholders and the bank.

Another problem that plagued the early waterworks, and divided the citizenry itself, was the move to incorporate the town of Folly as a city.

6.
THE 1960S AND '70S

On March 16, 1961, L.E. Stringer, Ralph Smith and James A. Stewart appeared before the South Carolina delegation to ask for legislation, if necessary, for incorporation if the voters favored it. In the discord that resulted, a suit was filed. The action was filed to block the election set for May 8 on whether Folly should remain a township or become a city. The bank would not loan Folly the money for the waterworks if the town was involved in litigation (this was one of the restrictions of the $250,000 loan), therefore, either the suit had to be dropped or the waterworks would have to be sacrificed.

On May 1, 1961, the action to block the Folly election was dropped. The attorney for the township commission, Hammond C. Bowman, said the suit was discontinued "because we do not want to lose a municipal water system." Lester E. Stringer was the attorney for residents in favor of the election on May 8. He said his group would postpone the election, but made it clear that the issue was for citizens to decide by vote, and it would be dealt with later.

Despite this rocky start, the 1960s were a golden age for Folly. Perhaps not as flamboyant as the '30s and '40s, Folly was still a place for families and young people to go and have a good time. Some of the notable people and places of Folly in the 1960s were Captain Jack Nathans, who was in charge of the volunteer rescue squad, and Troneck's Midget Market at 201 East Ashley Avenue—"Shop & Save at Midget Market" was their ad in the *Folly Beachcomber*. Kokomo's Lounge was on the corner of Center and Arctic Avenues and was owned by Clarence Smith. The Holliday Inn (run by the Holliday family) stood, as it still does, on West Ashley Avenue. On Center Street stood the Folly bowling center. Jack McLain and Dennis McKevlin were co-owners of the bowling center.

Bathing beauties and ads from the *Folly Beachcomber*, July 1, 1960.

Center Street with Morgan's Red Barn and part of the Folly bowling alley, 1968. *Stringer family collection.*

The Folly Souvenir & Bath House was at the Pavilion; the Seascape Apartments were located at 401 West Arctic; Folly Beach Rexall Drugs stood at 15 Center Street and the Beach Realty Co.—Wienges' Newsstand—was at 32 Center Street.

Vacation rentals were becoming more and more popular in the '60s. An ad in a 1960 *Folly Beachcomber* reads: "Spend your vacation at Folly Beach, for reservations, contact Beach Realty Co." Also in the *Beachcomber* in 1960, Folly's fire department's slogan was "Prevent Fires." Not real catchy, but succinct.

A radio ad for Folly from the 1960s went like this:

Folly is the one for you
It's got beach and sand and surfing too,
The in-crowd heads for Folly's sands,
Folly, that's where the action is.

It's swimming, rides, restaurants too
The fun crowd, the sun crowd
Goes to Folly Beach Park!

Stephen's five-and-dime was located at 20 Center Street, where Aida's Closet is now located. Rows of candy (sweet tarts, jawbreakers and Mary Janes, just to name a few) lined the glass counter behind which stood kindly Mr. Stephens. When you walked in, you were immediately welcomed with the musty smell of yellowed greeting cards, shell souvenirs, modest bathing suits and miscellaneous (hard to find) "parts" for home repair, all dating from the 1930s. It was like walking into a museum that happened to also be a candy store.

H&K's Super Esso service station was a well-known site on Folly located on Center Street where the Village Tackle Shop once stood. Currently the Seashell Restaurant occupies that corner. The Esso station was run by Herman Hagan and J.W. Koger.

Another 1960 ad in the *Folly Beachcomber* read:

Folly Beach Ocean Plaza welcomes you to 4 days of Labor Day Weekend, special feature "The Fireflies Quartet" when they play and sing, U tingl. Dancing to the music of the Tommy Garrett Orchestra.

On July 9, 1960, the Miss Universe pageant was held at the Folly Pier. Entertainers who appeared on the Pier in the 1960s were the Tams, the Drifters and Jerry Lee Lewis. Combined with the rides and carnival stands, the boardwalk area bustled in the '60s.

Folly's municipal growth also continued. On December 5, 1960, William J. Davids, firemaster, sent a letter to James A. Stuart and L.E. Stringer:

Dear Sirs:
In behalf of the local volunteer fire dept., I wish to extend appreciation for the many public service developments during your term of office.

Folly Pier, 1968. *Stringer family collection.*

Ocean Plaza, 1968. *Stringer family collection.*

Highways, water extension on the East end of the Island, with the installation of new fire hydrants, also the new fire hydrants on Center Street, rebuilding the Fire Dept. Tank Truck, construction of the new & much needed Fire Station. Purchase of fire hose and equipment for saving life and property, street lights, the Beach Front Plaza area and other every-day year-round public facilities, all of which has laid the foundation for a better and greater Folly Beach.

John F. McDonough, former township commissioner, retired on June 30, 1960. He had lived on Folly Beach since 1932 and was the first commissioner on Folly Beach. In December 1960, John B. Thomas resigned as township attorney for Folly Island. His term expired with the outgoing commissioners. Julian M. Bunch was chief of police; Frank Heinsohn was chairman; and Andrew P. Leventis Sr., Manning F. Bennett, Frank Hutto and John H. Inabinet were commissioners.

Anita M. Friar was the clerk in 1961. In January of 1962, Marlene Estridge was appointed clerk of the township starting March 1, 1962. As of the printing of this book, she is still city clerk and knows more about Folly than anybody.

In 1962, a riot gun and three fire extinguishers were bought. (It's hard to imagine Folly needing a riot gun, but you will be happy to know that the commission meeting minutes reflect that this equipment was to be "used only for police work.")

In February of 1964, there was a meeting with U.S. Army Corps of Engineers in reference to erosion on Folly Beach. The engineers estimated it would take $40,000 to study the problem. Erosion would continue to be a problem for Folly and is still a source of concern.

In July 1964, palm reading was banned on Folly. Another ban came in April of 1966, when a motion was passed prohibiting horse riding on the front beach between Tenth Street East and Eighth Street West from May 1 through Labor Day. Eventually, horses were prohibited from the front beach altogether. Sad, considering the grand legacy of the Mounted Horse Patrol, but necessary for safety's sake as there were large crowds of beach-goers and a spooked horse would have been a catastrophe. I imagine it was also a question of sanitation.

There is a notation in the minutes of the November 19, 1967 commissioners' meeting: "A new Santa Claus suit is to be ordered. Mr. Inabinet will contact Mr. Green about using the pier for the party." Of course, Santa visits Folly every year. He arrives on the fire truck at the end of the Christmas parade, sirens at full tilt. Each year, too, parents bring their kids to the pier or the police station or the library (also home of the Civic Club) and Santa gives each child a red mesh stocking filled with sparklers, oranges and candy. The younger children always go first and if there are enough stockings, even teenagers get one. When it comes to candy and sparklers, there is no pride.

In November 1967, John F. Wilbanks was welcomed to the Board of Township Commissioners. He initially served with Dr. Horres on the street, light and water departments. Later, he was named town manager. In January 1968, Ben Nance was appointed building inspector and chairman of the planning and zoning board. Billy Bresnihan was named electrical inspector for the island. In February of 1969, William Regan was the township attorney; Mr. Holmes was the attorney for the water department. Fred Adams, Tommy

Wienges, Harry Carter, Dorothy Sealey and Helen Barbrey were appointed to the zoning board, with Tommy Wienges as the acting chairman.

Of more importance than mere city offices, the *Folly Beachcomber* announced the summer league champs for 1960 for the Folly bowling center were Marlene Estridge, Jean Henderson, Merideth Tanner, Donald O'Neale, Ginnie Jamison and Rosemary Wolfe. Patty Knight, Larry McCutchen and Wallace Benson won trophies bowling in the junior tournament that year on Folly.

1970s

The 1970s, too, brought big changes to Folly Beach. It was at this time that the pier burned down for the last time, not to be replaced until 1995. With the pier's demise, Folly's tourist appeal diminished, withering into a shadow of its bright past. The crowds grew thinner; the ocean claimed more of the beachfront. Finally, the Pavilion closed. However, Folly's gradual decline as a tourist center was just that—gradual—and the community still thrived in areas of government and residential growth.

In August of 1970, the commissioners were John F. Wilbanks, Mr. Frank Heinsohn, Harry H. Carter, Marvin Estridge and James A. MeRee. Also in 1970, the census bureau indicated that the population of Folly Beach was about twelve hundred residents.

In 1971, the Civic Club conveyed three lots—41, 43 and 45 Center Street—to the Township of Folly. In 1975, the new community center was completed and the post office obtained an option on lots 103 and 104 East Huron Avenue as a site for a new post office. In May of 1972, Folly redeemed the waterworks bonds and paid off the waterworks.

On September 5, 1973, by a vote of two to one, Folly Beach was incorporated as a city with John W. Douglas as mayor. Councilmen were Fred J. Adams, Edward M. Smoak, Edward E. Wilder and Marvin C. Estridge. Mildred F. McBride was first city clerk of the new municipality; Henry Flood was chairman of the incorporation committee. Robert Hood was the city attorney in February of 1975.

On January 20, 1976, John F. Wilbanks resigned as city manager; in July of that year, Ben Peeples became city attorney. Rex Whitcomb was appointed chairman of the parks and recreation committee; Wallace Benson was chief of police. As of December 21, 1976, Dennis J. McKevlin was mayor pro tem, with Bill Lyles, Mr. Scott, Jackie Stringer, Herbert Alexander, Mr. Doscher and Regis Kennedy (who later served as mayor) as council members. In 1976, Rick Stringer was the judge on Folly and could sentence up to $200 fines or thirty days in jail. Our current judge is John Kachmarsky.

In April of 1974, the residents of Folly were shocked to discover Richard Valenti had killed three girls on the beach. He lived at 903 East Arctic Avenue and the bodies were found nearby. His victims were Mary Earline Bunch (age sixteen), Alexis Ann Latimer (thirteen) and Sherri Jan Clark (fourteen). Three other girls were found, alive, tied up under his house. If a Folly Beach police officer had not been investigating illegal surfing in the area, those three other girls may have been killed, too. Valenti was found guilty of murder and though he comes up for parole every two years, at the time of the printing of this book, he is still in jail.

Surfing

According to Rick Stringer, the first surfboard on Folly was owned by Pat Thomas. It was in July 1966 that the initial surfing controversy began. There were complaints about surfers around the fishing pier interfering with the fishermen's ability to catch. There were also concerns over danger to swimmers being hit by surfboards. An ordinance was passed prohibiting surfing within one hundred feet of the fishing pier. Dennis McKevlin appeared before the commission with several members of the Folly Surf Club to protest the area set aside for surfing as too restrictive, so the ordinance was rescinded. A new motion was passed, prohibiting use of surf boards and skim boards between Sixth Street East and Tenth Street West.

To make an incredibly long (and yes, somewhat boring) story short, the motions and ordinances flew back and forth, with discontented surfers and grumbling residents everywhere. In 1972, Tommy Bolus (president of Charleston Surfing Association) presented a proposal from area surfers at the commissioners' meeting. He stated that surfers would like the ordinance left as it had been amended in 1970. There must have been a hundred changes made on the surfing ordinance since it was first issued.

In 1975, Ben Peeples represented the surfers and filed a suit. Debate went back and forth. The surfers at one point offered to police themselves, withdraw the suit, open access lanes to the beach, help clean up the areas and help to erect signs. They were willing to include the costs of marking areas set aside for surfing if their proposals were accepted. There were several "marches" and a great deal of tension between various members of the government before the matter was settled. In 1975, the surfing ordinance was finalized. Now surfers are allowed at the Washout on the east end of Folly and within three hundred feet of the pier.

There seems to be little or no dispute about surfing now and in fact a few years back one of the highlights of the Christmas parade was the surfers from Ocean Sports marching with their surfboards, as if they were marines with rifles. They did really well, flipping the boards in unison.

7.
THE '80S AND BEYOND

As with every decade in Folly's history, the 1980s brought big changes. But on the whole, these changes would affect the community after the decade in which they occurred. The Holiday Inn was built in 1985 and new homes at Sunset Point on the Seabrook tract near the Sandbar Restaurant heralded huge changes to come for Folly. These changes materialized in the '90s and have continued unabated—condominiums are everywhere. Folly Road now has a Piggly Wiggly (a local grocery store for you Yankees). New houses, apartments and soon possibly a hotel, line Folly Road. Scrubby areas that were once ignored by the locals now are manicured and landscaped.

In the early '80s until the spring of 1989, Richard Beck was the mayor of Folly. Robert Linville was elected mayor in 1989 and held office until 1998, when Vernon Knox was elected. Marlene Estridge is our city clerk and Vivian Browning is her assistant. These two ladies have manned the front desk for some time now. Currently, Steve Robinson is public works director and George Tittle is public safety director. Our building official is Tom Hall. In 1991, Vicki Zick replaced Bill Griffin as city administrator when Bill left to pursue other interests in business. Our current city administrator is Toni Connor-Rooks.

Life on Folly in the 1980s, with the exception of the new hotel and a major hurricane, continued much the same as it ever had. Always ready for a party, Folly enjoyed annual festivals. The Float Frenzy was always one of our more quirky excuses for a party. The goal was to create an outlandish float and then, well, float down Folly River. Floats ranged from the imaginative lighthouse float by Jim and Kathy Nicklaus to an unnamed fellow with a styrofoam cooler full of beer. He floated. Prize categories were for most creative, fastest, slowest and everything in between. Karen Stringer runs the festivals. She says the Tides of March is usually on St. Patrick's Day weekend; Sea and Sand is usually in April; the Marshgrass Festival and Festival of the Arts are in October.

THE '80S AND BEYOND

West Ashley and Center Streets, showing Sand Dollar and Island Grocery (now 11 Center Street). Empty lot beside Sand Dollar in foreground is now Pavilion Watch. *Courtesy Nancy Thomas.*

Float Frenzy, 1995.

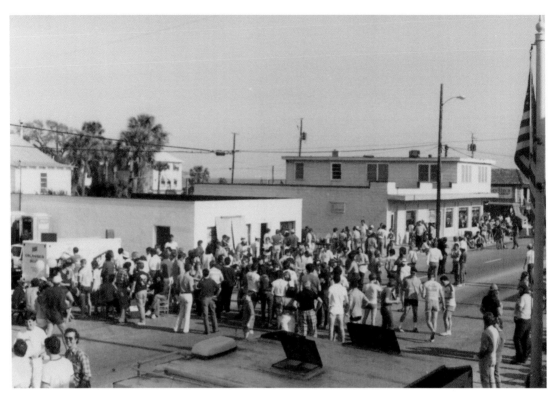

Festival on Center Street, 1983.

8.
PEOPLE AND PLACES OF FOLLY

Many of our more significant citizens, organizations and buildings flourished in the late 1930s and 1940s. The following is a brief summary of some of our more colorful and community-minded groups.

Post Office

Joy Stringer remembered that in the 1930s, "Mr. Campbell" owned a grocery store where McKevlin's Surf Shop is now. When people stopped by for a purchase, they'd also pick up their mail from Mr. Campbell. The post office officially opened May 1, 1932, and was run from various sites by Mrs. Rabon. There were two deliveries and two collections Monday through Saturday, with one delivery and collection on Sunday. After Mrs. Rabon, the postmasters were Mr. Regan, Manning Bennett, Mr. Perry, Clifton Wienges and James Ballard.

Previous locations, apart from Campbell's grocery, include the Newsstand, the barbershop, the pier and a garage behind the barbershop.

In 1940 Mrs. Ellsworth had a service station/grocery store/post office on Center Street where Shelton's Real Estate Office stood, later known as Beach Realty (the building is now being renovated). Manning Bennett served as postmaster. In June of 1941, that whole block burned to the ground. The post office was temporarily located on the Pavilion, where it stayed all that summer. In the fall of 1941, it was moved into a tin-roofed garage behind Roy Carter's house across from the police station. Sunlight streamed through the cracks in the walls; the floor had large knotholes and gaps. There was no air conditioning and the heat was magnified by the tin roof. The post office stayed there until 1950.

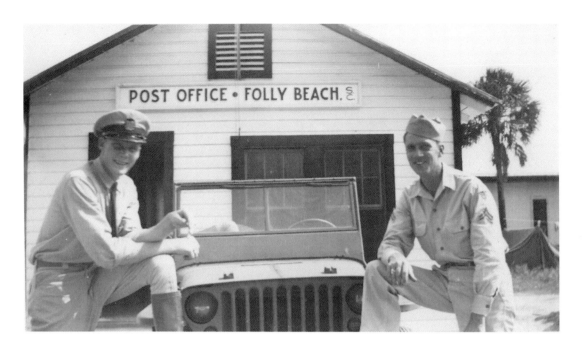

Folly post office, 1940s.

Planet Follywood (old post office).

When Jimmy Ballard started at the post office in 1947, Mrs. Josepha Pinckney Hill was the senior clerk. Her daughter, Betty Hill Hansbury, also clerked there. In 1989, when I spoke with him, Mr. Ballard said:

In the Spring of 1950, we moved to Mazo's store right across from the A&M [11 Center Street now]. They partitioned it off and made a separate place…We stayed there until 1954 when Kitty and Tommy Wienges built the post office on the corner of Erie and Center Street, where Turtle Corner is now. That was the greatest thing that ever happened to Folly Beach.

The post office was at Center and East Erie (at one point known as Turtle Corner, currently Planet Follywood) until 1978, when it was moved to the new building on Huron Street. Mr. Ballard was there until January of 1980. He worked for the postal service a total of thirty-three years. Joy Stringer worked there from 1959 to 1985, a total of twenty-six years. Virginia Hopkins worked from 1964 to 1983, a total of almost twenty years.

Jimmy Ballard and Joy Stringer said the oddest thing they remember delivering was a birthday cake that was mailed in a bakery box with a cellophane top. You could see the cake. A child from up north addressed it to "Uncle Joe, P.O. Box Whatever." When it was delivered, there was not a crack in the icing; the cake was in perfect condition.

Mr. Ballard said:

We've handled packages mailed in burlap bags. We've had them mailed in wooden cases. They used to mail chickens out here, too. The first beehive we got, they were all outside the bag. The queen was still in the bag and the bees were trying to get back in.

The next postmaster was L.D. Suggs, who started on Folly on July 12, 1980. Our current postmaster is Joanne Johnson and now Marcel Toulouse and Miquel Aguayo make sure Folly's mail gets delivered.

The Civic Club

On October 11, 1940, the Civic Club began under Frank Heinsohn Sr. Ours was one of the first Civic Clubs formed in the United States. The property, located on the corner of West Huron and Center Streets, was deeded to Folly by the Civic Club with the stipulation that the site always be used as a civic club. The original community center was salvaged from the area where the Santee Dam was being built. It was a dining hall and was moved by Harry Beckmann. The floor always sloped and the sills rotted off but the community loved it. My Girl Scout Troop met in that square white building amid the smell of musty books. We kids would run over the slant of the wooden floor and sit at picnic tables inside. The building housed Folly's library, and church services and Red Cross meetings were held there free of charge, as were business, political and civic meetings. The Civic Club sponsored oyster roasts around the barbecue pit in the back. Longtime residents remember cold October nights and the smoky smell of oysters at the Civic Club. Unfortunately, membership has dwindled so

7181

The State of South Carolina | **CERTIFICATE OF INCORPORATION**
EXECUTIVE DEPARTMENT | BY THE SECRETARY OF STATE

WHEREAS, John F. Wilbanks, 202 West Erie Avenue, Folly Island, S. C.

F. A. Neely, 1459 Burningtree Road, Charleston, S. C.

Ben R. Nance, III, 410 East Hudson Avenue, Folly Island, S. C.

two or more of the officers or agents appointed to supervise or manage the affairs of

FOLLY ISLAND CIVIC CLUB

which has been duly and regularly organized, did on the 24th day of February, A.D. 1966, file with the Secretary of State a written declaration setting forth:

That, at a meeting of the aforesaid organization held pursuant to the by-laws or regulations of the said organization, they were authorized and directed to apply for incorporation.

That, the said organization holds, or desires to hold, property in common for Religious, Educational, Social, Fraternal, Charitable or other eleemosynary purpose, or any two or more of said purposes, and is not organized for the purpose of profit or gain to the members, otherwise than is above stated, nor for the insurance of life, health, accident or property; and that three days' notice in the Charleston Evening Post, a newspaper published in the County of Charleston, has been given that the aforesaid Declaration would be filed.

AND WHEREAS, Said Declarants and Petitioners further declared and affirmed:

FIRST: Their names and residences are as above given.

SECOND: The name of the proposed Corporation is FOLLY ISLAND CIVIC CLUB

THIRD: The place at which it proposes to have its headquarters or be located is Folly Island, S. C.

FOURTH: The purpose of the said proposed Corporation is to promote acquaintance, friendship and fellowship as an opportunity for Service. To encourage and foster the ideal of Service, and to provide opportunity for its members to be of Service to youth, to less fortunate of their fellowmen, and to the community. To create higher civic principle, and to promote co-operation in all business and civic affairs. To provide through its club meetings opportunity for the full and free discussion of matters of public interest. To promote in every way good citizenship; to encourage good government; and to further mutual tolerance and understanding to the people of the community.

FIFTH: The names and residences of all Managers, Trustees, Directors or other officers are as follows:

John F. Wilbanks	202 W. Erie Ave.	President
F. A. Neely	1459 Burningtree Rd.	1st Vice President
W. W. McBride	2131 E. Ashley Ave.	2nd Vice President
Ben R. Nance, III	410 E. Hudson Ave.	Secty-Treas.

SIXTH: That they desire to be incorporated: in perpetuity

Now, THEREFORE, I, O. FRANK THORNTON, Secretary of State, by virtue of the authority in me vested, by Chapter 12, Title 12, Code of 1962, and Acts amendatory thereto, do hereby declare the said organization to be a body politic and corporate, with all the rights, powers, privileges and immunities, and subject to all the limitations and liabilities, conferred by said Chapter 12, Title 12, Code of 1962, and Acts amendatory thereto.

GIVEN under my hand and the seal of the State, at Columbia, this 24th day of February, in the year of our Lord one thousand nine hundred and 66 and in the one hundred and 90th year of the Independence of the United States of America.

O. FRANK THORNTON,
Secretary of State.

Certificate of incorporation of the Folly Island Civic Club, 1966.

much that the Folly Civic Club has almost disappeared, so all you residents and property owners need to sign up!

The new Civic Club building was built in the mid-70s and our council meetings and various other community affairs are held there. Currently, a new fine arts center is in the works to be built as a second story on the community center.

The Garden Club

The Folly Beach Garden Club was officially organized on January 27, 1950. The president was Mrs. John Steel and there were thirty members at that time. In addition to sprucing up the beach, the Garden Club sponsors other community activities.

Churches

Initially, Folly's citizens met in the Green Tea Room on Center Street for services, then they used Larry's Grill for a while. There were two interdenominational churches on Folly. One was a Community Church at 109 West Indian; the other was Faith Chapel, which burned, located at 201 East Cooper Street. Initially the Faith Chapel met only in the summer. The Community Church met all year. Faith Chapel was predominately Baptist and was started by Citadel Square

Our Lady of Good Counsel Catholic church, ca. 1960s. *Stringer family collection.*

Baptist Church as a mission in July of 1947. H.H. Brown donated the original property where the Baptist church stands today. The Methodist church has been on Folly since 1942.

Our Lady of Good Counsel, the Catholic church on Center Street and East Indian, was built in 1950. Prior to that, the Catholics met at the Elks Club in the 1000 block (East) on the front beach.

The Library

Tommy Wienges says Folly's first library was run by Lottie Olney, a retired teacher, at her home at 105 East Ashley. The collection was originally started by donations from residents, then Ms. Olney contracted with the county library to obtain books. Later, the library moved where the present Civic Club stands.

In October of 1961, Dorothy Turner was librarian on Folly. Working with her was Dorothy Sealey, who would later become librarian for Folly. After twenty years as librarian, Dorothy Sealey retired in 1986. Kathy Nicklaus began as our librarian in August of 1987 then Ralph Freeman manned the front desk until March 1998, when Kathy returned. Kathy retired in 2004. Terry Brown is branch manager now.

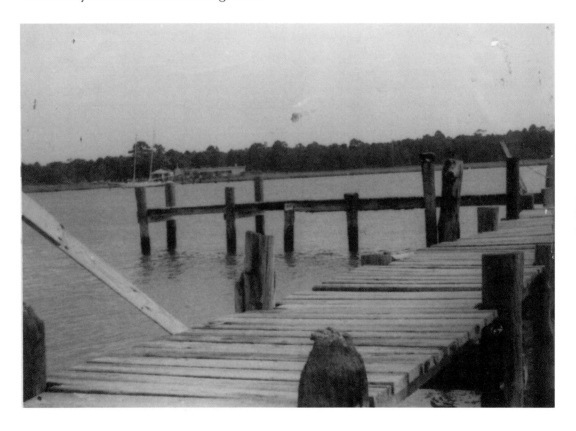

View of the Sandbar Restaurant from the Third Dock on Little Oak Island (Mariner's Cay), 1970s. *Stringer family collection.*

The Sandbar Restaurant

Located on the Folly River, on the west end of the island, the Sandbar Restaurant is one of Folly's more notable landmarks. Initially Michael and Margaret McCarthy sold sodas and chips from a tackle shop to the people crabbing and fishing on the dock there. Their business evolved and eventually, they sold hot dogs and simple sandwiches and a small building was erected where the Sandbar stands today. Then they began serving seafood.

In 1969, Darus and Muriel Weathers took over the business and over the course of several years, the restaurant grew. Many special occasions have been celebrated there over a fine dinner. Now the restaurant is known as River Café at the Sandbar.

Baptist Beach House

Another well-known building was the Baptist Beach House. It stood on West Ashley Avenue. A two-story building, it was built in the early 1930s and was made entirely of cypress. The house was run by M.L. McLeod as a hotel for a few years and was officially called The Beach House. During World War II, the coast guard used it as a barracks.

The building had been deeded to the Columbia Bible College. Eventually, it was deeded to the First Baptist Church of Charleston and became known as the Baptist Beach House. There was a stipulation that the church could not sell the property. It was used for conferences and for activities for the underprivileged as well as other groups. It burned in 1972.

The Newsstand

In 1938, Tommy and Kitty Wienges (practically Folly landmarks themselves) first ran an open-air newsstand where Planet Follywood now stands on the corner of Center and Erie Streets. They then operated where Fred Holland Realty is now at East Huron and Center. Mrs. Harper gave the Wiengeses their first real estate accounts and rented the Newsstand that many of us remember, on the corner of Center and East Hudson. The Wienges named their company Beach Realty Co., and while they sold real estate, they also rented vacation homes. The steps to the Newsstand stood for many years after the building was demolished.

Any kid from Folly could come in to the Newsstand, order a Coke and read the comics (without buying them). In the 1940s through the 1960s, the Newsstand was a family restaurant as well as a party place for navy guys and their dates. Somehow, all these different groups—families, teenagers, sailors—never clashed. Everyone knew everyone else and the various ages all got along.

Fred P. Holland Realty

LaJuan Kennedy says Holland Realty started in October of 1973, in the same spot it stands now on Center Street. She came on board in March of 1974. Fred and Eloise Holland lived in Myrtle Beach and would come down once a week or so. They had a realty office up there. Initially, they

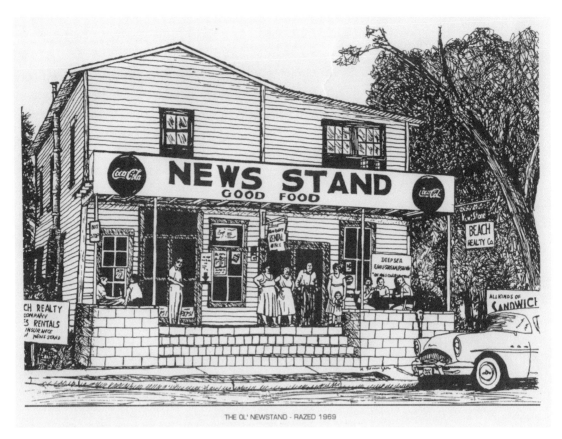

The Newsstand, ca. 1960s. *Drawing by Karen Stringer.*

focused on sales, but when they realized their competition, Beach Realty, was handling all the rentals on Folly, they decided to expand. Lest you think there was cutthroat competition, LaJuan says they made a point of not contacting clients of Beach Realty. Whenever Tommy and Kitty Wienges went on vacation, they left the keys to their office with Holland Realty.

City Hall

The original city hall was a small cinderblock building that housed the jail and city offices. I must admit I don't know the year it was built. It stood where the current city hall stands. Though much smaller than today's structure, it was sufficient until recent years, when Folly's growth made the building obsolete. You walked in the front door and immediately before you was a window where Mrs. Pat Pierce would direct you to either the city offices or the police. Mrs. Pierce was city dispatcher from October 1976 to March of 1990. Hers was always a voice of calm.

In 1997, work was completed on the new city hall, called "Bob's Mahall" by some, or "Linville's Folly" by others as a jibe to the then-mayor, Bob Linville. The building is large by some standards, and it holds our jail, our police offices and our city offices; the fire department

FOLLY BEACH MUNICIPAL BUILDING

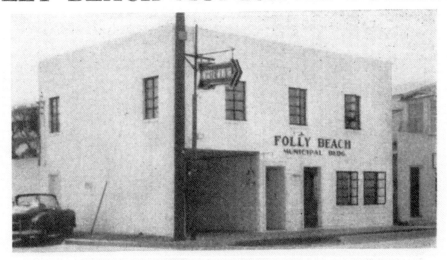

The Folly Beach Township Commissioners Extend To You A Most Cordial Welcome To Our Beautiful Beach

This image of the Folly municipal building as it appeared in the July 1, 1960 *Folly Beachcomber.*

is right behind it. The old city hall was in bad shape when it was finally replaced and the new one, though perhaps a little too "pretty" for some, will serve its function for many years.

Smoak's Rent-A-Float

Longtime resident Rick Stringer recalls that in the early 1960s, he, along with George Steele and Larry Walker, started working for Smoaky, (Edward Smoak) at Smoak's Rent-A-Float. He remembers:

> *I had the center stand and Karen and Jackie* [Stringer] *had a stand down to the west end of the plaza and Wallace and Jessica* [Benson] *had a stand farther down by the Atlantic House which was originally Owen's stand…We used to have "runners" as we called them. I had Pete Altman as my runner and he'd run after the rafts when the time would expire. He would go search and try to find them.*
>
> *We rented the floats for 50¢ an hour for the regular ones, 75¢ an hour for the bigger, yellow, two-man rafts. The umbrellas were 50¢ an hour and they were $2.50 all day. If we rented an all-day, we had to get the license plate number and identification.*
>
> *The Pier in the summertime almost always had somebody up there, if not during the week playing music, at least during the weekends—Fats Domino, Jerry Lee Lewis, the Zodiacs. In the afternoon, we used to generally go surfing if the tide was right.*

Smoak's Rent-A-Float, 1968. *Stringer family collection.*

Rick met Cheryl Hanna on the beach in the early summer of 1966 and another marriage resulted from a summer at Folly. Kenny Bush, Mickey Owens, John Thomas, Larry Walker, George Steele, Dicky Benson, Ira Mcdonald, Janice Brown, Libby Ecklund, Mary Sue Smoak, Eddie Strange, Bernie Messervy and Lester Schwartz and Paul Schwartz worked the float stands, too.

Other Landmarks

Another "famous" building is 503 East Ashley, with its Alaskan totem pole. At one time bronze lions guarded the doorway, and two Greek goddesses, also bronze, kept watch over the premises. Inside were old circus posters and a whale's jawbone. These oddities were the collection of Herman Shindler, an antiques dealer on King Street. Children said the place was haunted; it was certainly interesting.

George Gershwin stayed at Charles T. Tamsberg's cottage at 708 West Arctic Avenue in 1934 and wrote *Porgy and Bess* while there. His friend DuBose Heyward had written the novel *Porgy* and invited Gershwin to the area to absorb the local customs and collaborate on the play. Heyward's home was a few doors down from the cottage Gershwin rented and has since been restored by the current owners. While here, Gershwin judged a local beauty contest. Apparently he started out rather dapper, but as he stayed at Folly, Gershwin "went native"—he stopped shaving and gave up wearing a shirt. He felt Folly was a tropical island, somehow

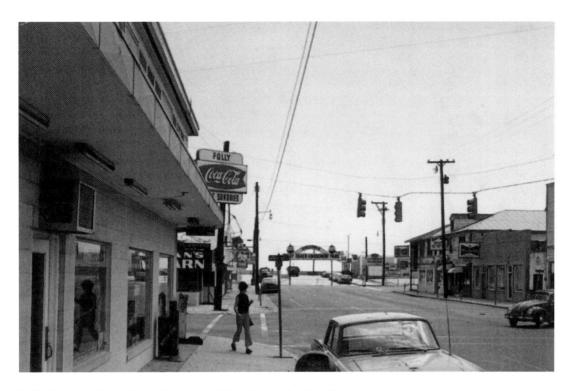

Folly Drug Sundries, Center Street, ca. 1960s. *Stringer family collection.*

attached to the United States, but basically separate. I know several Folly residents who would agree with him.

Another "historic" building was McNally's. It was the hangout for teenagers and young adults in the 1930s and 1940s. The building stood on the corner of Center Street and Atlantic Avenue (1 and 3 Center Street), and had apartments on the upper story. Right in the middle of the building and protruding out of the roof stood a live palmetto tree. McNally's burned to the ground in the 1960s. The Pavilion Watch condos are there now.

In the 1930s and 1940s, the building on the corner of Center and East Ashley was owned by David Mazo and was the only grocery on Folly. Mr. Mazo gave credit freely. The stock clerk, Priestly, would drive people back home with their groceries once they'd made their purchases. Mr. Mazo used to have hayrides for the kids. He'd fill a station wagon with hay and take them trundling down the roads of Folly. Later, he set up chairs in the back of his store and put in a jukebox. The youngsters would dance and people would throw pennies! Later, H.W. Wilbanks opened a sundry shop in that location. Eventually Florence Wilbanks ran the shop; she served grilled food and milk shakes too.

On the corner of Center and East Cooper, Mr. John's Beach Store opened in 1951. When John and Rachel Chrysostom first opened their business, they called it The Folly Beach Rexall, and it was across on the opposite side of Center Street. Son Paul Chrysostom says they sold sundries and also had a pharmacy with an old-fashioned soda fountain. Rachel was a licensed pharmacist and "Mr. John," as we called him, did taxes during the off-season. In the 1960s, they crossed Center Street

Mr. John's Beach Store.

"Old" city hall, ca. 1989.

Shark over "old" Ocean Sports surf shop. The new municipal building is next door.

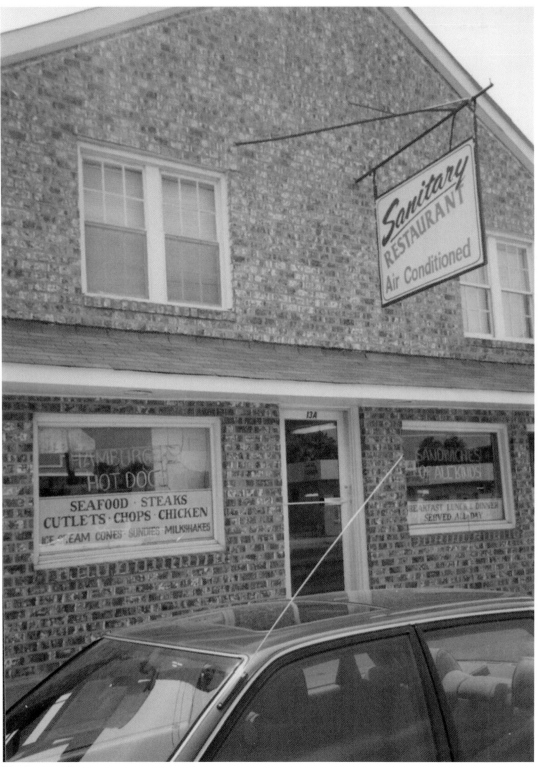

The Sanitary Restaurant, 1980s.

The Lost Dog Café on Center Street.

and eventually renamed the business the Beach Store. When his dad passed on, Paul Chrysostom renamed the store Mr. John's Beach Store to honor his father. Locals call it Mr. John's.

The Sand Dollar Social Club also deserves a nod. At first glance, the dark gray/green color and the fact that the windows are boarded over might make one think it's a rough place. The fact that there are usually five or so Harleys out front might make you hesitate to step inside, too. (But remember, most motorcyclists nowadays are professionals seeking to recapture the freedom of the highway.) The Sand Dollar stands on Center Street, between Ashley Avenue and the Pavilion Watch condominiums. Many years ago, it was the Rip Tide. And, yes, it's probably not a place to take your mom on Mothers Day. But owner Richard Weatherford makes sure no one steps too far out of line.

Dennis McKevlin said he opened his first surf shop on Folly in 1965. It was a nine-by-forty-foot area behind the bowling alley. His oldest son ran it. They organized surfing contests. Hopefully there will always be a McKevlin's Surf Shop on Folly.

Ocean Surf has become a Folly landmark in its own right. Owners Bill Perry and Bettie Sue Cowsert are regular fixtures on the beach. They took over the Natural Art Surf Shop at 19 Center Street, renaming it Oceans Sports (now Ocean Surf) and later built the building they are in now, at 31 Center Street.

Another local favorite, the Sanitary Restaurant, closed in 1998. Ms. Lottie Harvey ran it for fifty years. The hamburgers were thick, the coffee was strong and the atmosphere was

The Atlantic House, ca. 1970s. *Stringer family collection.*

very fifties-diner. After a little modernizing, the Lost Dog Café, run by Carol and Paul Greve, opened on that spot in 2002. By spring of 2006, "the Dog" will be moved to 103 West Huron. The hamburgers are still thick, the coffee is still strong and the atmosphere, while not fifties-diner, is still welcoming. An interesting note on the new home for the Dog is that during the renovation, the words "Bingo 10¢" were uncovered painted on the side of the building. The building had been a laundromat before Carol and Paul bought it, but I do not know of a bingo parlor there. Apparently, however, there was one at one time.

A place that is still near to my heart is Pete's Hot Dogs, run by Pete Manos. Located at the end of the first block on the east side of the beach, the front porch faced the ocean and you could watch the waves while you enjoyed a hot dog and beer. Resident Karen Stringer says it "cured" her of vegetarianism. I remember sitting on that porch with my husband-to-be, hearing John Denver sing "Sunshine on my Shoulders" as we watched the waves sparkle. Hokey, yes. But these are the things memories are made of.

So many people have fond memories of dinning and partying at the Atlantic House; it is a shame it's gone. Eddie Taylor owned the house, which stood on the beachfront at the end of the first block. With the ocean actually running up under the house at medium to high tide, the building was doomed during Hurricane Hugo. Because of zoning restrictions, Mr. Taylor was not allowed to rebuild when the building washed away in 1989.

Another local favorite is Bert's Supermarket, owned by Bert Hastings, at 202 East Ashley. Prior to that, Chris Zecopoulos and Jerry Spetseris ran it as Chris and Jerry's, and before them it was Troneck's Midget Market. Folly's other grocery store was on the corner of Center and West Ashley—now known as 11 Center Street. It was the A&M, run by the Merritts, who later ran Turtle Corner where Planet Follywood now stands.

Grace McNally, mid-1930s. *Stringer family collection.*

Folly's People

Folly has always been filled with interesting characters—like "Aunt Gussy," as the kids of the 1930s called her. A large woman who stood excruciatingly straight, Aunt Gussy often took in children from broken homes. On Halloween she would always have a special treat for the neighborhood children. She would dress in a loose gown with stars and moons on it and tell fortunes. She always managed to scare the kids pretty well and they loved it. Aunt Gussy owned several cabins at 410 East Erie and all over the yard on Halloween she'd have tubs set up to bob for apples.

Murray Benson created East Folly Shores and named all of the streets there. Emory Asbell owned the Esso station in the late 1930s. He was *the* eligible bachelor on Folly, and he was snagged by Sue Tinken, who ran the Tea Room where Mr. John's Beach Store is now. They were the talk of Folly Beach because they went out a couple of times.

In the 1940s, Mrs. Secker was the city clerk and as such held a great deal of power on Folly. She took an active interest in her job and retired on December 31, 1956, after over fifteen years of service to Folly. In the 1930s and 1940s, Grace McNally did everything, including running McNally's. She and her roomer, Pappy Stacey, had a dog, also named Pappy. They would give the dog a note and send him to the drug store to get them ice cream cones. (They paid the tab later.)

Romeo sold eggs in the 1930s. He lived in an old streetcar on Folly. No one knew his real name, but he looked Italian, so he was called Romeo. He'd call, "Fresh eggs, fresh eggs, Romeo's got fresh eggs."

Mr. Wagner was a commissioner for years and he ran a wholesale peanut place in town. Not surprisingly, he was nicknamed "Peanuts" Wagner. Jimmy Ballard, a previous postmaster, has been mentioned before. An interesting note about him is that he was a prisoner of war in World War II. When he arrived at Folly, he was incredibly thin. He had a wonderful echoing laugh and his mom made great peanut butter and banana sandwiches for us.

In the 1970s, Folly had a laundromat on Center Street, next to the then-post office (now Planet Follywood). It was run by Annie Grace Albenesius and did a thriving business. You could either do your own laundry or you could leave it and Mrs. Albenesius would do it for you.

A most colorful character, and one of my personal favorites from Folly, was nicknamed "Blackie." His real name is Henry Jastremski and he has since moved from the beach (our loss). Looking the epitome of a sea captain, Blackie was partial to white shirts, big black boots that he tucked his pant legs into and a captain's hat. He always wore a medal on a chain around his neck. He had the prettiest blue eyes framed, by the time I got to know him, with the most wonderful wrinkles. At one time, he had coal black hair and a black beard, hence the nickname "Blackie." In his youth he ferried folks across the Folly River before the bridge was built and the story goes that many a female tourist felt he was quite dashing. He was an incredibly sweet man to all of us little Folly urchins. On his birthday, he always bought us kids candy from Andre's tackle shop (they sold tackle, bait, beer and candy). Years later it dawned on me that he seemed to have several birthdays every year—I was not the sharpest kid on the block. For me, he's part pirate and part saint, personifying life on Folly River in a simpler time.

9.
THE PIER AND PAVILION

Perhaps no landmarks were as well known and loved as the Folly Pier and Pavilion. The beachfront at Folly was owned in 1918 by Folly Island Co. and in 1919 by Folly Beach Corporation. In the 1920s, the Pavilion, a wooden open-air building, was on the corner of Center and East Arctic. Manning Bennett's hotel was to the west of it. In later years that building on the corner of Center Street and East Arctic Avenue was Folly's bowling alley, the Dancing Bear and, later, Monk's Corner. The last two were, obviously, bars. Café Suzanne's currently inhabits that corner.

In the 1930s, the Pavilion was located where the Holiday Inn now stands. It sat on a concrete boardwalk built up from the beach. Like its predecessor, it was a wooden open-air seating area that housed various grills and arcade games as well as a bathhouse, newspaper stand, umbrella rental and a soda shop. The Pavilion boasted "sanitary bath houses" where bathers could shower before leaving the beach.

The Folly Pier and Pavilion area was initially known as the Atlantic Boardwalk. It opened in June of 1931 at a cost of $50,000 and was built by Ted Shiadaressi, who ran it for almost two decades. At the grand opening there were six hundred to a thousand people present and the mayor of Charleston, Thomas P. Stoney, was the guest speaker. The Marshall Van Poole Orchestra played on opening night.

At that time, the boardwalk was made up of wooden planks with large cracks for drainage. The main entrance was on Center Street. The Pavilion stood to the right of the entryway; there were various concession stands on either side of the building. On Arctic Street East a small carnival was set up every spring and removed every fall. The kids always waited anxiously for the merry-go-round to come down. Centrifugal force caused unwary

Folly Beach souvenir folder, ca. 1940s.

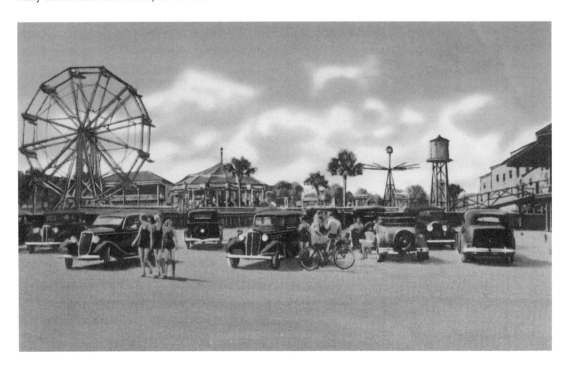

"Folly's Playground" from Folly Beach souvenir folder, ca. 1940s.

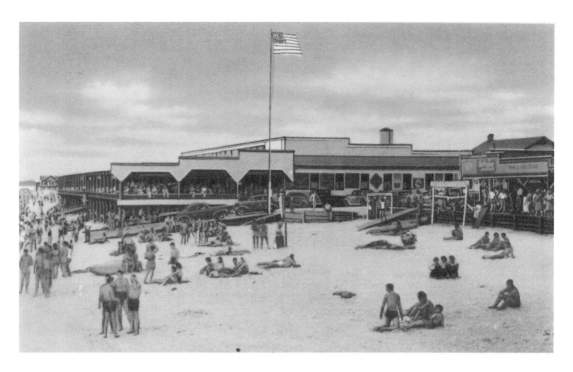

View of the Atlantic Pavilion, from Folly Beach souvenir folder, ca. 1940s.

riders to lose dimes and nickels, which would fall between the slats on the ride. The kids would "clean up" every fall.

Immediately in front of the amusement park, jutting out into the ocean, stood the Folly Pier. It was green and white, 120 feet wide and 97 feet long, with palmetto logs as its main building material. Couples danced under a revolving crystal ball. Tommy Wienges was one of the members of the dance committee on the pier and he said that there were five members of the committee. Four had dates; the fifth always arrived alone and would dance with the dateless girls until the girls were asked to dance. What a sacrifice! The committee stood in the middle of the dance floor and the others danced around them. It was all very polite and the gentlemen wore coats and ties. Tommy and Kitty Wienges met at the pier and became permanent dance partners. I imagine the waves and the music brought together quite a few couples at Folly.

On the Fourth of July 1937 there were over fifteen thousand people at the pier. At that time, Harry James, Guy Lombardo and the Ink Spots were famous entertainers who appeared there. Folly was doing well. In 1948, Louis Lempesis bought the boardwalk. Other owners include Lester Karow and Thomas Marks.

On April 19, 1957, at 5:30 p.m., the Ocean Front Hotel and Pavilion burned. First reports stated that a plane crashed into the Pavilion, but this was later found to be false. The flames rose fifty feet over the building and damage was estimated at $200,000. Kokomo's Lounge, the Ocean Front Hotel and Joe's Restaurant went up in flames, and the fire threatened to spread farther down Center Street.

FOLLY BEACH

Jimmy Ballard and June Wood dancing on the Folly Pier in the 1950s. *Stringer family collection.*

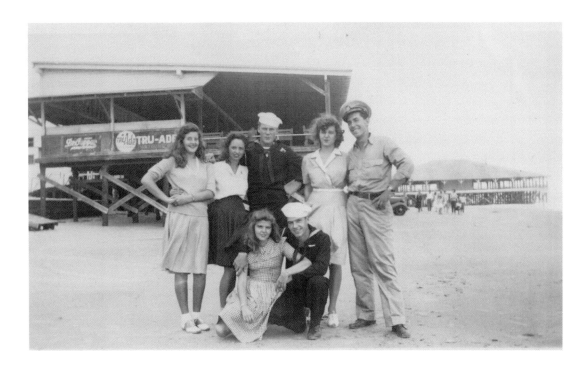

Folly Pier and Pavilion, 1940s. *Stringer family collection.*

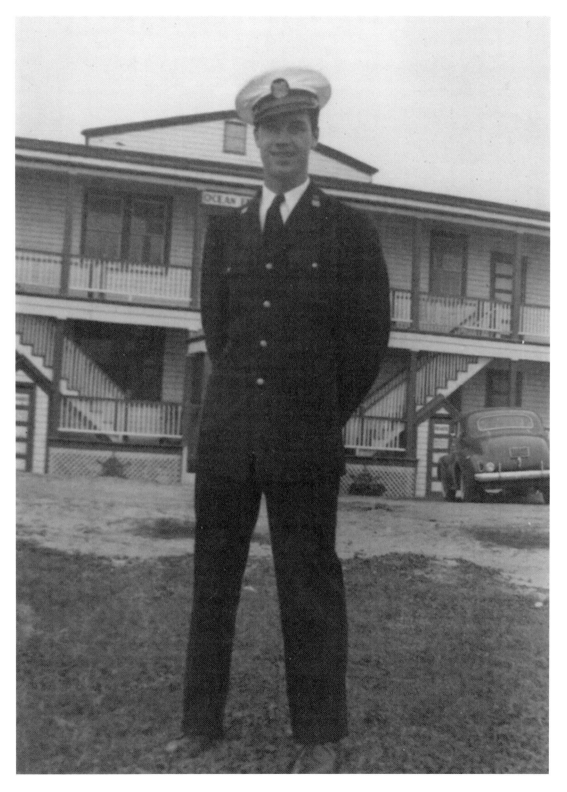

Ed Stringer at the Ocean Front Hotel, mid-1940s. *Stringer family collection.*

Smoldering remains of the Folly Pier, 1957.

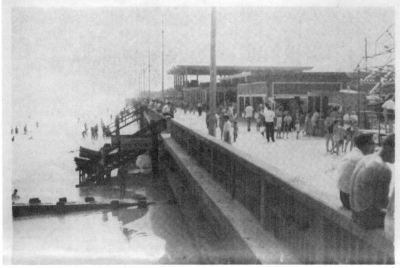

Grand opening of Ocean Plaza, from the *Folly Beachcomber*, July 27, 1960.

Folly Beach Ocean Plaza
GRAND OPENING
July 28, 29, 30

We Have Provided These Facilities For Your Enjoyment And Pleasure:

1700 Feet of Fully-Lighted Boardwalk

Bath House And Souvenir Shop

Four Food And Beverage Concessions

Newly Remodeled Plaza Pier For Dining And Dancing

15 Amusement Rides—Strates Shows By Endy Productions

12 Game Concessions

Raft Concessions — 8 Moaski's

Skateland — Top Deck Ocean View

GRAND OPENING SCHEDULE:

THURSDAY, JULY 28 — Grand Opening Festivities

4:00 High Wire Acts
 Hi Pole Act—Bob Johnson; Aerial Contortionist—Miriam Frantz.

5:00 Ribbon-Cutting Ceremonies
 Address by State Senator T. Allen Legare, Jr.
 Master of Ceremonies—Joseph P. Riley

6:00 Tour of Ocean Plaza Facilities

7:00 Buffet Supper for Invited Guests

8:00 Fireworks Display

9:00 Dean Hudson and his Orchestra on the Pier

FRIDAY, JULY 29

4:00 High Wire Acts

9:00 Dean Hudson and his Orchestra on the Pier

SATURDAY, JULY 30

4:00 High Wire Acts

8:00-
12:00 Dean Hudson and his Orchestra on the Pier

This announcement of the Ocean Plaza's opening festivities appeared in the July 27, 1960 *Folly Beachcomber.*

It took firefighters two hours to control the flames; the blaze could be seen from Charleston. The only injuries came about by people involved in a wreck on Folly Road as they rushed to see the fire. The pier was not damaged.

The pier and Pavilion re-opened in July of 1960 as the Ocean Plaza. Strom Thurmond, Olin B. Johnson and State Representative L. Mendel Rivers, as well as Ernest Hollings, were guests. The new building was designed by Demetrios C. Liollio and was advertised as one of the most outstanding plazas on the eastern seaboard. The members of the board of directors were J. Louis Lempesis, president; George S. Croffead, vice-president; Andrew P. Leventis, treasurer; Peter C. Gazes, secretary; and James Clekis, second vice-president.

The Ocean Plaza consisted of seventeen hundred feet of boardwalk, with a bathhouse and souvenir shop, four food and beverage concessions and a remodeled plaza and pier. It also had fifteen amusement rides, twelve game concessions, raft concessions and a skate rink upstairs. The grand opening was scheduled for July 28 and featured high-wire acts, a ribbon cutting

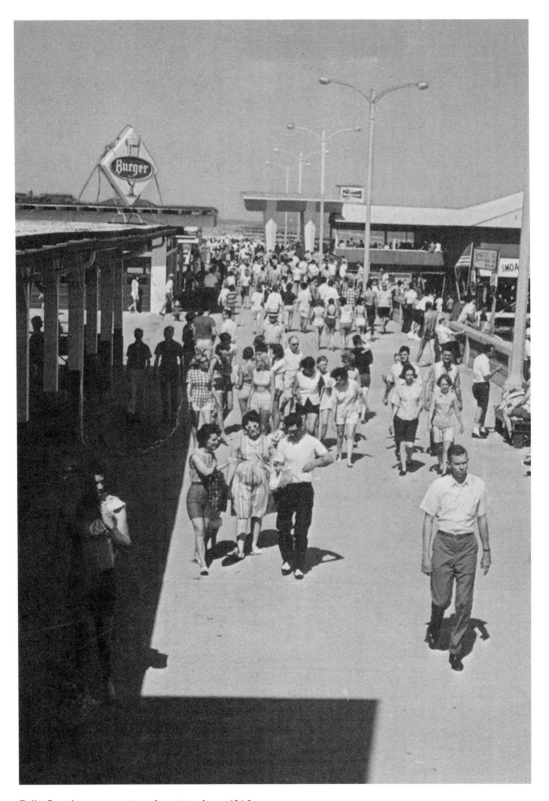

Folly Beach amusement park postcard, ca. 1960s.

Folly Beach amusement park, ca. 1962. *Stringer family collection.*

ceremony and a tour. Later there was a buffet supper for invited guests, a fireworks display and entertainment by Dean Hutson and his orchestra on the pier. The festivities continued on Friday and Saturday.

On the dirt section along Arctic Street East loomed the Ferris wheel, surrounded by the tilt-a-whirl, bumper-cars, the Crazy Mouse roller coaster and other rides. As in the past, every spring the owners of the pier and Pavilion would put up the rides and every fall they would take them down.

On hot summer days, the sounds of the crowds and the carnival music combined with those of the bands from the pier and wafted over Folly River to our little haven behind Andre's tackle shop. We would walk over Folly Bridge and inhale the smells of cotton candy and tanning lotion blended with the summer night-ocean smell of Folly. The lights from the Ferris wheel always dazzled; the crowd (sunburned and giddy on lights and music) always fascinated. Folly was sort of wild then, but still somehow safe enough for kids to walk around without worry.

My husband, Ed Robinson, remembers working at Mrs. Santos's cotton candy stand. It stood on the left of the main entryway to the Pavilion. He says:

> *We sold cotton candy, candied apples, popcorn, roasted peanuts, freezies* [a sort of 7-11 slush-like drink] *and snow cones. The candied apples were coated with hard red candy and Mrs. Santos would dip them there in the stand. There was no air conditioning, of course. It was basically a wooden open-air stand. It would get hot, what with the popcorn popping, the*

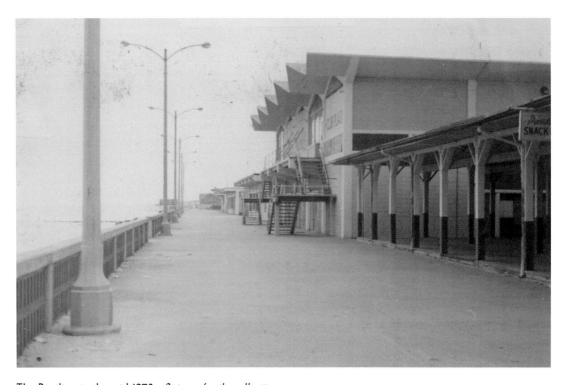

The Pavilion in the mid-1970s. *Stringer family collection.*

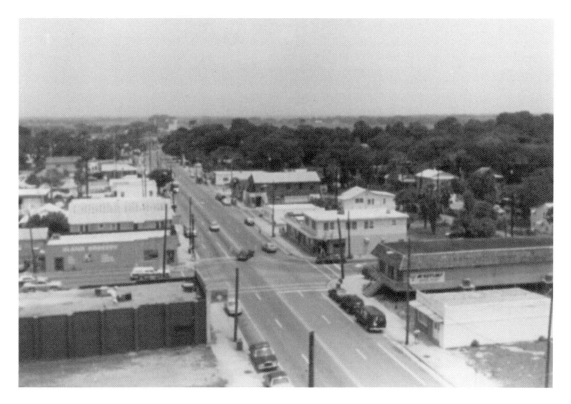
View of Center Street from Holiday Inn, 1980s. *Courtesy Nancy Thomas.*

cotton candy machine going, roasting peanuts and dipping apples in the hot red candy mixture. But I was fifteen and just came down from Youngstown, Ohio. I was in heaven.

Ed went on to say that during the day, people would come up from the beach in their bathing suits for snacks and something cold to drink, but in the evenings, they were dressed nicely. You never saw a bathing suit in the evening. He also says that, especially during the fourth of July, the line at his stand blocked the boardwalk. He didn't even have time to flirt with the pretty girls.

In later years, the amusement park was closed down and removed; the pier was used for community activities—Santa came at Christmas and there was a Halloween party every year. The bands no longer came to Folly.

Prior to the final fire in January of 1977, the pier was owned by Folly Investments and Folly Plaza. There were rumors that the fire was purposefully set, perhaps by vagrants, but no one was ever prosecuted. The area was in bad need of repair afterward and generally deteriorated. Eventually, the remains of the pier had to be removed.

In 1980, the boardwalk at Folly was sold back to Folly Beach Amusement Park, Inc., for $500 at a master's sale. The owners had originally bought it in 1978 for $850,000. The Folly Beach Amusement Park, Inc., was the only bidder at the auction.

In 1985, the Holiday Inn was built on the beachfront. There was a lot of controversy over it, with posters up and down Center Street crying: "Where's the beach?" a spoof on the memorable Wendy's commercial, showing tiny people dwarfed by a huge hotel. Some said the hotel would bring more development to the island and there were people for and against it.

In 1995, the present-day pier was built. It extends 1,045 feet and boasts a restaurant and gift shop. For a small fee, a daily fishing license enables you to cast your line for almost any kind of fish you can think of. While most people know it as the "Folly Beach Pier," its official name is the Edwin S. Taylor Pier.

10.
SHARKS AND OTHER FOLLY WILDLIFE

Let's face it, sharks and alligators are just naturally interesting, what with those big teeth and all. E. Milby Burton in "Shark Attacks along the South Carolina Coast," a 1935 article in *Scientific Monthly*, states that in the 1930s there were several shark attacks along our coast. In June of 1935, a young boy was swimming at the north end of Morris Island and he saw a shark fin. He decided to stay in about three feet of water, feeling that would be safe. Burton quotes the young man:

> *"I felt a swerve of water, which was immediately followed by an impact, which brought me to my senses. Something clamped down on my right leg. I was aware of a tearing pain up and down my leg, and that I was being pulled outward by something which seemed to have the power of a horse. Looking down, I saw, amid the foam and splashing, the head of a large shark with my knee it its mouth, shaking it as a puppy would shake a stick in attempting to take it away from some one."*

The boy kicked and the shark let go—only so it could chomp down on the other leg! He continued kicking the head of the shark, which he said seemed "as solid as Gibraltar," while pulling himself backward toward the shore. All of this only took seconds, resulting in a ten-inch impression of the shark's teeth on the boy's leg. A witness from the shore states that the shark was easily eight feet long.

Burton goes on to state that two eight-foot sharks were caught near where this incident occurred. His article is based on medical records and witness statements and he recounts several events on Folly, one of which resulted in a shark's tooth being removed from the victim. He cites attacks in the James Island Sound and near Coles Island as well. Luckily, none of these people

died as a result of the attacks. Again, these are incidents from the '30s, when one must assume there were more sharks and fewer people. Although one can't be too careful.

In "Observations of Inshore South Carolina Sharks 1967 to 2000," Rick Stringer discusses the various sharks he has tagged in over thirty years of wandering the inlets and rivers. The Atlantic sharpnose shark is the most numerous, in fact representing over 50 percent of the sharks Stringer captured during warmer weather. The blacktip comes in second, and the spiny dogfish and sandbar sharks are numerous too. Over the years, Rick has captured and measured twenty-one species of sharks in our waters. The sandbar shark was more prevalent prior to 1987; the largest sandbar he measured was seven feet, three inches. Usually the females are larger than the males. Unfortunately, the sandbar shark population is declining, probably due to overfishing.

Atlantic sharpnose shark (remember, the most numerous) often feed in packs. They are voracious eaters and Rick cites a catch of a juvenile only nine inches long that ate a mullet about the same size. Adult sharpnose seem to prefer the ocean, although mature males have been caught in the Stono, Kiawah and Folly Rivers in early spring and summer. The sharpnose seem to be flourishing with the demise of the blacktip and other shark species.

Blacktip sharks have been captured in inshore waters, usually in the surf zone. They jump out of the water when feeding on menhaden and other small fish. Adult blacktip average five to six feet and weigh between 70 and 115 pounds. They mate in inshore local waters in the spring.

Our waters also host spinner, dusky and tiger sharks. Tiger sharks can be very large—in Cherry Grove, South Carolina, a 1,780-pound tiger was captured, a world record. They seem to like the old drill minefield area off Folly's shores. They don't seem to like the shallow, inshore waters. Good thing. Rick has had a nine-foot tiger jump when hooked and one tiger fought for five hours.

Bull sharks are bottom dwellers and they like the waters around Folly and Morris Islands, particularly when the shrimpers are out. Unfortunately, Rick has not captured a large bull shark since 1988. The great hammerhead frequents our area and many juvenile scalloped hammerhead are captured on the pier, where they are released. The great hammerhead can reach up to eighteen feet. Unfortunately, again, Rick has not seen a large great hammerhead in our waters since 1981.

Don't forget the bonnethead shark, the lemon shark or the blacknose shark. Oh, and the finetooth shark, the mako and the silky. And lest you feel you can disregard all of the above, we do have great white sharks in our waters. In December 1995, Rick tagged a seven-foot-long, 250-pound immature male great white.

Of course, there are other animals living in and near the ocean. Porpoises sport in the ocean and feed in the marshes. Folly's marshes were home for alligators in our not-so-distant past, although I am not sure they were quite as large as the Union soldiers might have imagined. My mother told me once that they used to bellow at night, looking for a sweetheart. I know for a fact that a poor, lonely (well, I don't know if he was lonely) alligator lived in a cage behind Andre's Tackle Shop for a few years. He'd been caught by my uncle, Homer Wood. He didn't move much, just hissed at us, which explains my younger sister's

childhood "thing" about alligators. He disappeared one day, pen and all, and we were told he was taken to Charles Towne Landing. I hope so.

In Folly's Civil War days, in addition to alligators, we had bobcats too. I don't know that anyone has seen a bobcat on Folly in a generation or two. But, of all the creatures mentioned by the Union soldiers, we do still see turtles on our beach. Every year the preservation group Turtle Watch helps monitor and sometimes move turtle nests. Usually in May, after crawling up onto our sands and laying their eggs, the mama turtles head north to the Outer Banks of North Carolina, or the waters of New Jersey and the Chesapeake Bay. Sometime around July or August the hatchlings start appearing on our beaches. Unfortunately, before they get to the Atlantic (where there are other predators), the baby turtles have several hurdles to overcome: ants, seagulls and man-made lighting are just a few. Hatchlings just naturally head into the light and they can't tell the difference between a porch light and the reflection of the moon on the ocean. That is why residents are cautioned to turn out their outdoor lights. It is extremely important to minimize the light pollution from the houses located from 1500 to 1700 East Ashley. If at all possible, even interior lighting should be muted. SCE&G has installed cobra covers on the streetlights and installed yellow lights to help control the light pollution. So, remember to keep those lights off as much as possible!

The recent renourishment of the beach also tends to disorient the hatchlings, but Turtle Watch does an amazing job, sometimes transplanting several clutches to new nests. A nest was even found on Morris Island. If you see some wooden stakes with orange tape wrapped around them, the best thing you can do is to leave them alone. Although, I must confess, early one summer morning I was walking on the beach with two of my sisters when we discovered thirty or so hatchlings running for the ocean. We resisted the urge to pick them up (you should never, ever do that) and carry them to the waves, but we couldn't resist the urge to scream and yell and flail our arms like crazy women, to scare off the seagulls looking for breakfast. It was amazing!

Since Folly is a bird sanctuary and hosts one of the few remaining maritime forests at the east end of the beach, I am sure bird watchers like to come to Folly. We have the aforementioned gulls by the ton, but we also have pelicans flying in V formation, whippoorwills, mockingbirds and all the regulars.

Certainly, our wildlife has been affected by the encroachment of man. We build houses on the front beach, we bulldoze sand dunes where sea turtles lay their eggs, we boat and jet ski where porpoise play and we built the jetties in Charleston Harbor. According to Gered Lennon in the *Compendium of Field Trips of South Carolina Geology*, the two forces of man's encroachment and the natural migration of shoreline landward has destroyed wetlands and beaches. When the Charleston jetties were built in 1898, they altered the coastal processes and exacerbated the erosion on Folly and Morris Islands. Although Folly and Morris acquired additional sediment (accretion) for twenty-five to thirty years immediately after the jetties were built, this stopped in the 1930s. By then, however, roads and homes had been built on Folly. The jetties removed the Charleston ebb tide delta and exposed Folly and Morris Islands to winter storms. Folly has lost four to six feet of shoreline each year since the 1930s.

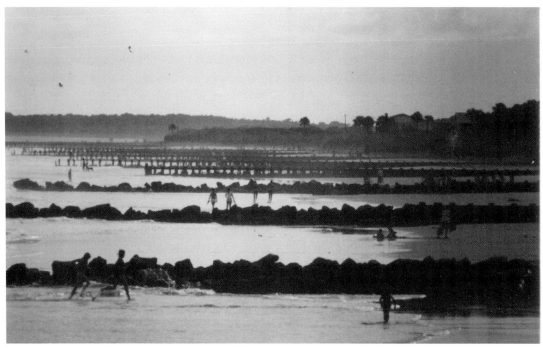

Groins on Folly, ca. 1970s. *Courtesy Les Stringer.*

In the 1940s, the groins were built to try and slow the erosion. Initially, they were made of creosote timbers, and set a thousand feet apart. Later, rock was used and in the 1950s, additional groins were added. These worked fairly well until Hurricane Hugo, although even before the hurricane, we continued to lose ground. In the '60s, landowners began building seawalls, which have not helped the matter and may in fact cause damage. The erosion control line, or "Statewide Retreat Policy," was initiated in 1983 by the South Carolina Coastal Council. Unfortunately, in 1990, Folly was granted special guidelines under the Beachfront Management Act and so Folly is exempt from the Statewide Retreat Policy. Additionally, homeowners are now allowed to rebuild their seawalls. So, basically the powers that be made a policy and then exempted the area that is most affected by it.

That's how we come to have the Beach Shore Protection Project, a fifty-year project that began in May of 1993 to renourish the beach. Every eight years or so, sediment is to be pumped onto the front beach. Unfortunately, according to the College of Charleston Department of Geology, the majority of the first batch of sediment pumped onto the beach was eroded away approximately two years later.

Today, it is difficult to get a permit to build groins, as it has been proven that they have a negative impact on the beach ecosystem. Beach nourishment is about the best fix, but it is temporary and expensive. Additionally, beach nourishment merely encourages development, which quite honestly is not a great idea on an island that is eroding away. The problem, of course, lies with the public officials who bend to pressure from developers, ignoring the petitions of the locals.

II.
Hurricanes

One thing locals can tell you is if you hear the words "mandatory evacuation" you should leave the island. Hurricanes and tropical storms are very much a part of life in the Lowcountry. We are threatened yearly with near misses. Hurricanes produce winds from seventy-five to over two hundred miles per hour, and of course result in wind damage and tidal surges. A tide of eight feet above mean sea level will cause serious flooding over exit roads (like Folly Road). With a projection of ten feet above mean sea level, residents are usually advised to evacuate.

All of the following information comes from Laylon Wayne Jordan's *History of Storms on the South Carolina Coast* and John C. Purvis's *South Carolina Hurricanes*, both of which can be found in the Charleston County Library's South Carolina Room. These reports focus on Charleston, listing surrounding areas only rarely. Only the storms that affected Folly or which have some other particular point of interest are listed here.

The earliest record of a hurricane was September 4–5, 1686. The storm disrupted a Spanish attack on "the lower Carolina settlements." There is, of course, no mention of Folly Beach or any other Sea Island. In 1700, a hurricane flooded the streets of Charleston and wrecked *The Rising Sun*. All of the Scottish settlers aboard were killed. In the early 1700s, hurricanes or tropical storms ran many ships aground and caused property damage. On September 15, 1752, a ship from Sullivan's Island was driven six miles north of Charleston into Clouter's Creek, to Shute's Folly. It was undamaged.

In 1854, Charleston suffered $300,000 damage by ninety-mile-per-hour winds. On August 25, 1885:

> *Extreme storm winds S.E. 90–100 m.p.h. in Charleston. Swept entire coast. Property damage from wind and water in excess of $2,000,000.00. In Charleston, all wharfs but one were destroyed and 90% of all buildings were injured. The iron steamship Glenlivet was torn from her moorings and driven up the Ashley River where it swept away several hundred feet of the new bridge. All the lowlands were flooded, roads rendered impassable; whole forests leveled. The damage to sea island cotton estimated at 3/4 of the crop…several pilot boats were sunk with all hands lost…a village on St. Helena Island was wiped out and all residents drowned except one woman. Altogether a death toll of 21.* [Named] *"The August Cyclone."*

On October 2, 1898, a storm with winds from 50 to 70 miles per hour partially submerged the southern lowlands and the islands in a fourteen-foot storm surge. In August of 1911, there was a storm with winds from 94 to 106 miles per hour that hit between Charleston and Beaufort. There were seventeen deaths and property damage was estimated at $1,000,000. "The Isle of Palms reportedly improved by leveling of sand dunes."

On September 18, 1928, twelve to sixteen inches of rain and winds at seventy-five miles per hour caused damage at Folly:

> *FOLLY BEACH devastated by high tides with homes, pavilion and 15 feet of beach washed away. Power company and roadway damage is severe. Many communities isolated. Property damage exceeded $3,000,000.00.*

Storms also brought damage in 1934, 1940 and 1947.

Hazel was a powerful hurricane that made landfall on October 15, 1954. The winds were from the southeast and reached 106 miles per hour at Georgetown and Myrtle Beach. Entire communities were swept away; twenty-foot high dunes disappeared; property loss was estimated at $27,000,000. Amazingly, there was only one death.

Gracie made her appearance on September 29, 1959. She had southeasterly winds at eighty miles per hour and a storm surge of 8.6 feet. Luckily, the storm arrived at dead low water. Property loss was estimated at $12,000,000 and there were eleven deaths. The Sea Islands were almost totally evacuated. Both Hazel and Gracie demolished homes on Folly, causing some to topple completely over, leaving others shifted sideways. These two hurricanes were the worst to hit Folly Beach—until Hugo, of course.

In 1979, David, a spent hurricane, hit Charleston at normal high tide, with fifty-six-mile-per-hour winds and a storm surge of eight to nine feet, or two to three feet above normal high tide. Folly Beach had several badly damaged homes, but on the whole, David was a dud. My memory of David is putting up with the heat and mosquitoes when the power was out.

Hurricane Hugo blundered into the area on September 21, 1989. Although for us this was the storm of the century, Hugo's destruction certainly cannot match Katrina or Rita. However, in terms of development, Hugo had a lasting effect on Folly Beach.

Hugo was such a large hurricane, it affected several counties of South Carolina with 135 mile-per-hour winds and gusts of up to 150 miles per hour. Twenty-six people died in South

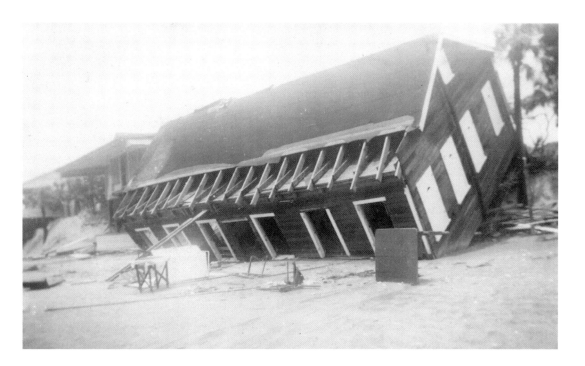

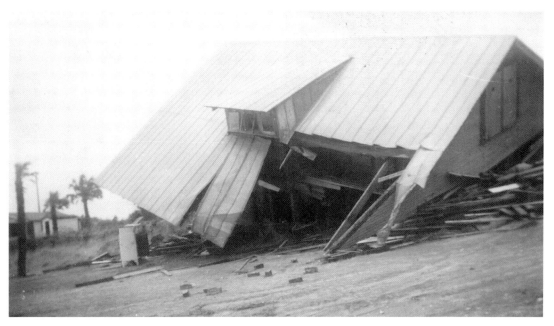

Damage from the storm of 1947. *Stringer family collection.*

Carolina as a result of the hurricane and $4 billion in damages occurred to the state. It's amazing no one died on Folly, but that was only because the city officials did such a great job of clearing everyone off the island. By 1:00 p.m. on Thursday, September 21, the island was completely evacuated.

When the residents of Folly Beach tried to return home on Friday, they first had to drive from out of town, past the uprooted trees and twisted billboards that lined the sides of the interstate. There was no electricity as far away as Columbia, so gasoline was a problem. If you didn't have enough in your car by the time you hit Columbia, you weren't going to make it home. In a way, it didn't matter because most people parked at South Windermere and began walking. The police had closed Folly Road because it was impassable, what with telephone poles, trees, electrical wires and debris from houses scattered all over it. In addition, the road was covered with two feet of marsh grass, so you can be certain Folly Road was well under water during the hurricane.

As the roadway was cleared, a roadblock was set up by the National Guard at Crosby's Seafood. Only residents were allowed on the island. I think the weirdest part about the roadblock was seeing guys in fatigues, strangers you didn't know, scrutinizing you and questioning your right to go home. After a while, some Folly Beachers were there, too, and that made it more acceptable. I'm sure, too, that the roadblock helped cut down on any looting that might have occurred.

After passing the roadblock, returning residents could see that the incomplete Mariner's Cay Inn (since demolished and replaced by Turn of the River condos) had been gutted; the dock

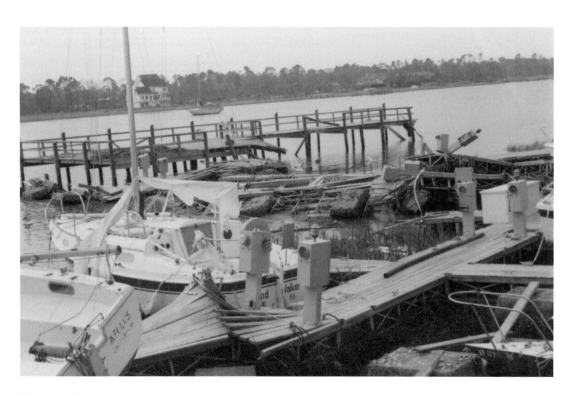

Hurricane Hugo damage.

on the Mariner's Cay side of the Folly Bridge had been destroyed, with boats and debris piled up around it and clustered around the bridge. It looked like a giant child had swiped a bunch of little toy boats aside.

Arctic Avenue was covered with sand and many of the connecting side streets were washed out. The Atlantic House was gone. Only some pilings remained in the sand and bits of roof lay where the parking lot had been. The ground floor of the Holiday Inn was partially destroyed.

Individual houses were completely gone. Others were partially destroyed; you could drive by and look into a front window that looked perfectly normal, until you realized the back of the house was gone and you were looking at sky. Down by the Washout, a whole row of houses was destroyed. One house, in particular, looked as though Godzilla had come and taken a huge bite out of the back of it. Some houses were shifted slightly, having been moved off their foundations by the winds. Often hurricanes spawn twisters and one house would be perfectly fine while the next was totally demolished. A live dolphin was found inside a home on Folly. It was returned to the ocean, none the worse for wear. That sounds like Folly, doesn't it?

On Friday, the twenty-second, SCE&G turned off gas to the island because of leaks. The water was also shut off, but the water in the tank was still good for cleaning. Folly residents lined up with the rest of eastern South Carolina for water. Strangely enough, phone service was still functional.

The mayor at the time, Bob Linville, and his wife, Carol, along with several others, organized a relief effort for the citizens of Folly Beach based at the Civic Center. Food, water, tarpaper and plastic for roofs, wood and other miscellaneous items were available. Some areas of Folly went without electricity for as long as three weeks. The water from the tank could be used for cleaning purposes, but could not be used for drinking for as long as four weeks.

Of course, Hugo was a major catastrophic event; it cost millions of dollars in damage and resulted in massive anxiety for hundreds and hundreds of people. But it also drew neighbors closer together. When you get a bunch of guys together with chainsaws to clear roads, you just naturally have camaraderie. When you have a freezer full of food that isn't frozen anymore, you have a cookout—especially when you have to cook *out* because there's no electricity to cook *in*. And when you have no electricity and no TV, you get more creative for entertainment. Did I mention the baby boom nine months after the storm?

Anyway, Folly and the surrounding areas survived Hugo with flying colors. The only lasting unfortunate aspect of Hugo was the loss of so many old homes, which were replaced by new homes, which seems to have led to condos and even bigger homes. But I'm an old-timer.

12.
Surrounding Areas

No history of Folly Beach would be complete without mentioning the surrounding areas, several of which are now officially part of the City of Folly Beach. Morris Island, Ebener's Island (Mariner's Cay) and other islands have all affected Folly's history.

Morris Island

In the 1940 publication *Charleston, An Epic of Carolina*, Robert Goodwyn Rhett states:

> *Morris Island begins with Cumming's Point, one mile south of Fort Sumter, and runs south along the ocean for four miles, where it is separated by Lighthouse Creek from Folly Island, a narrow strip of sand dunes running southwest for seven miles and separated from Kiawah Island by the Stono River.*

Aside from the fact that Folly is more than a "narrow strip of sand dunes," Morris Island is no longer four miles long. Originally it was made of three small islands, the northernmost being Cumming's Point (nearest Charleston). The center island was Morrisons Island. The southernmost island, Middle Bay Island, was given to the United States government because the Charleston Light was located there. This is the only remaining portion of Morris Island. Lighthouse Creek separates Morris and James Islands; Lighthouse Inlet, or Morris Island Inlet, separates Morris and Folly.

During the Civil War, Morris Island was home to two Confederate batteries, Battery Gregg (named after Brigadier General Maxcy Gregg) on Cumming's Point and Battery Wagner, originally a "small sand fortification" called the Neck Battery, which of course became Fort

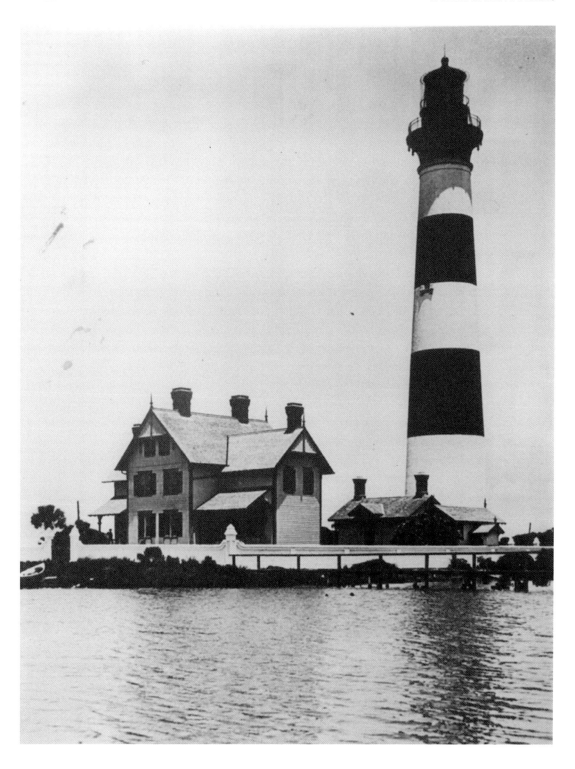

Morris Island. *Benson family collection.*

Wagner and saw heavy combat. There was also apparently a hospital for plague and cholera victims on Morris Island at one point. I don't know what use it was put to during the Civil War, but in *Stories of Charleston Harbor* it is stated that a gale in 1878 damaged the hospital on Morris Island and the patients were moved to James Island.

Aside from its role in the Civil War, Morris Island has been the site of a lighthouse for over two hundred years, though not always the same banded structure we see now. The Charleston Lighthouse, on Morris Island, is listed as one of the eight first lighthouses built in the colonies. It is recorded that in 1695, the Seventy-first Highlanders were sent to the lighthouse on a mission to help unload artillery and powder for the protection of the infant settlement. While there is no physical proof of the existence of this first lighthouse, it is entirely plausible, especially in view of the order of the Seventy-first Highlanders. This first lighthouse would probably have burned pitch in open braziers.

In 1767, a small octagonal tower, which probably burned fish oil in a "spider" lamp, stood on Morris Island. The height and other markings of this lighthouse are unknown. It is, however, the first recorded lighthouse on the island. When the second lighthouse was removed, a lead plate was found with an etching of this 1767 lighthouse. This is the only physical evidence of the first lighthouse that we have. The plate also listed the name of the reigning king of England, as well as the governor and lieutenant governor of the Province of South Carolina.

A storm in 1854 destroyed the lighthouse keeper's house and the lighthouse on Morris Island. The second recorded lighthouse was built in 1857. This lighthouse used a fixed white light and stood 133 feet above sea level. The tower was white. This lighthouse was destroyed during the Civil War, although the Confederates used the hull as a lookout station.

The present lighthouse was built in 1876. The tower is 155 feet high and it is banded in black and white (though today and in artists' renditions the stripes appear rust red because of weathering). There are nine flights of iron stairs. The brick tower is 33 feet in diameter at the base and stands on a foundation of 264 piles with concrete and rubble masonry. The light from the tower was 50,000 candlepower with a visibility of nineteen miles at sea. Its foundation is an engineering marvel, designed and built by Peter Conover Hains, a major in the Army Corps of Engineers. The August 2001 newsletter and the website of the Save the Light Foundation, the citizen group working to preserve the Morris Island Light, recounts Major Hains's fascinating career. He not only fired the first shot in the battle of Bull Run and received numerous awards for bravery, but was actually called back for active duty in 1916 by a special act of Congress. At the age of seventy-six, Major General Hains was the oldest solider in uniform, and the only Civil War officer to serve in World War I. He had designed the foundation of the Morris Island Light well enough to withstand the earthquake of 1886, as well as the constant pounding of surf.

A lighthouse keeper usually lives in the lighthouse or a house adjacent to the lighthouse. The last lighthouse keeper for the Morris Island Lighthouse was Captain William Hecker. Captain Hecker and his family lived on Morris Island for fourteen years, after moving there in the spring of 1925. One of their six children was born on the island. Ester Hecker was in labor during a storm and though for her prior pregnancies she had been taken to Charleston, the storm made that impossible. A doctor was called to the island, but

couldn't get to them. His father, also a doctor, did make it. The baby was named Ester and nicknamed "Storm Baby."

Joy Stringer recounted to me that she went to school with a girl who lived on Morris Island. If it was high tide after school, her friend would stay on Folly or her father would boat over and pick her up. If the tide was low, she walked home.

Eventually, since there were five children on the island and a spare building that could be used as a school, the county provided a teacher. Elma Bradham would come over by boat and stay Monday through Friday, returning to the mainland for the weekend. Later, Marl B. Kline took over the teaching responsibilities. One of assistant keeper W.A. Davis's daughters rented a room on Folly and went to school in Charleston during the week, returning home to the island on the weekends, because she was too old to attend school on the island. Initially there were four lightkeepers, but in the 1930s, this was lowered to three and then two. Captain Hecker and W.A. Davis were the last two lightkeepers. On June 22, 1938, the lighthouse was mechanized. After that, it only required monthly inspections and the keeper's house was moved and the other building destroyed.

Unlike a lighthouse keeper, a lighthouse tender does not live at the lighthouse, but, as the name implies, periodically tends to the lighthouse. Cliff Benson was the last lighthouse tender for the Morris Island Light. The light was decommissioned in 1962. He remembers that the light had four acetylene tanks at the time, with a Fresnel lens. He first tended the lighthouse in 1956. Mr. Benson is very clear that he was a lighthouse tender as opposed to a lighthouse keeper. By the time Mr. Benson was working there, there was no house to stay in on the island.

Pamphlet for the Save the Light Foundation, ca. 2000.

Views of Morris Island Lighthouse (above and right), early 1970s. *Courtesy Les Stringer.*

Today this incredible building is in very bad shape, and the Save the Light Foundation is currently working to preserve it. Save the Light is trying, sometimes it seems without success, to get funding for structural repairs before another hurricane comes along and demolishes the historic lighthouse.

Ebener's Island (Little Oak or Mariner's Cay)

Little Oak Island was originally known as Ebener's Island. Most of the island was incorporated into Folly Beach on March 31, 1981. Ebener's Island was not very large at all when it first came into being. From the Mariner's Cay guard post, the island is now mostly filled-in. Apparently "Old Man Ebener" sold a portion of the island to Andre Thevenot. He in turn sold a portion to John McDonough, who gave both daughters a portion of his portion. Thevenot still owned the majority of the island. When he died from an accidental gunshot wound during a domestic quarrel, he left his property to his granddaughter, Renee Gaillard. She, or her trustee, sold the island to Mariner's Cay Development who built Mariner's Cay.

Before all the condos and pavement, though, the island consisted of a dirt road with three docks, two or three homes and a shed near the present site of the guardhouse. Leading around the shed along the riverside ran a small path that afforded a beautiful view of Folly River.

Folly Beach

My family lived on Ebener's Island. Our neighbors at one time were Andre Thevenot and his wife, who lived in the house that eventually became "the Dumbwaiter," where the Mariner's Cay Inn once stood and where Turn of River is now, on Folly Road right before the Folly Bridge.

Andre's daughter, Sarah Mae, and her family lived in a house near the front entryway to Mariner's Cay; next to them was a house that sheltered various families at one time or another (ours included). My grandparents lived in the house where Rick and Cheryl Stringer live now; my aunt, June Wood, and her family lived next door. My family lived in the last house at the end of the road. In all, six families lived on the island at one time or another. In the later years, before Mariner's Cay, only Stringers and their kin lived there. It was a wonderful place to grow up, filled with woods and docks and shrimpboats for kids to explore.

We were very creative in our titles for the docks—they were "the Three Docks." What we called the First Dock was the one still standing, right by the bridge. The Second Dock was down by Mariner's Cay. The shrimpboats would dock there. It was a great place for ghost stories. The Third Dock was at the marina at Mariner's Cay. There they repaired boats. It had a huge crane-like apparatus that would lift the boats out of the water to be worked on. It also had a shed that housed boat tools. The dock was an upside down *L*. The Third Dock also had a little open-windowed stand, with a big brick tub sort of thing where they would pack ice and tackle and beer. It always looked like a mausoleum to me. Some good blackberries grew around that shack. The Third Dock was the most adventuresome dock by the time I was old

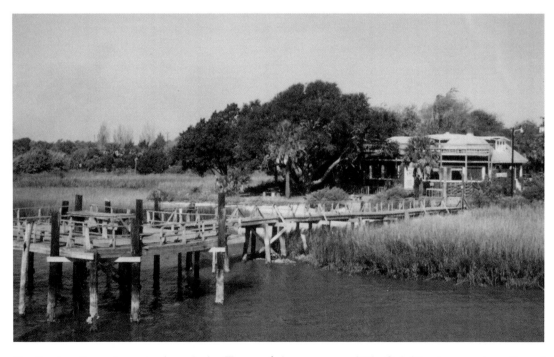

The Dumbwaiter restaurant, where Andre Thevenot's house was on Little Oak Island, now where Turn of River is, ca. mid-1970s. *Stringer family collection.*

Folly Bridge and the First Dock before Turn of River, 1990s.

Foot of Folly Bridge, before Turn of River, early 1990s.

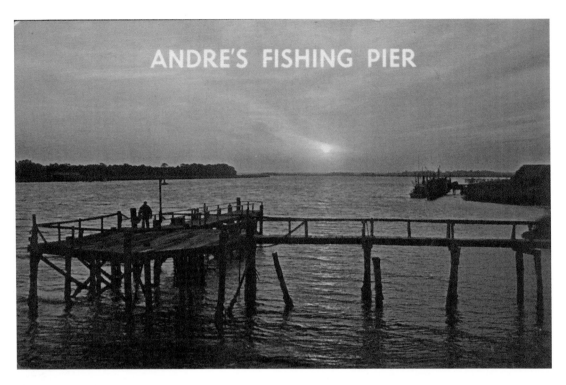

Andre's fishing pier, ca. 1970s.

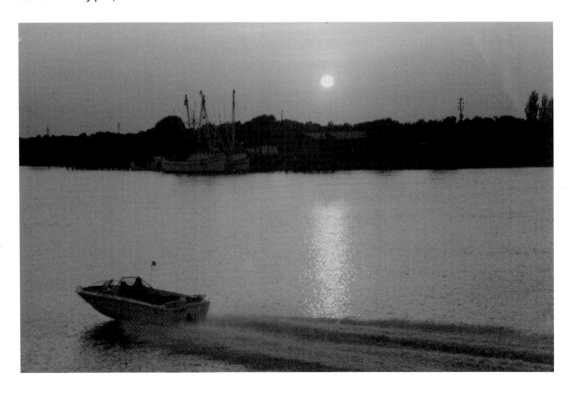

Folly River, looking at Second Dock on Little Oak Island (Mariner's Cay), late 1970s.

The road to the Third Dock, Little Oak Island (Mariner's Cay), mid-1970s. *Stringer family collection.*

Boat repair building at Third Dock on Little Oak Island (Mariner's Cay), 1970s. *Stringer family collection.*

Amy, Michael, Sandra and Donna Stringer running along the Third Dock on Little Oak Island (Mariner's Cay). The bait building is gone and this photo shows a mausoleum-type cement block box that was used for bait. Ca. 1970s. *Stringer family collection.*

Third Dock (Mariner's Cay) with a building for bait, about 1970s. *Stringer family collection.*

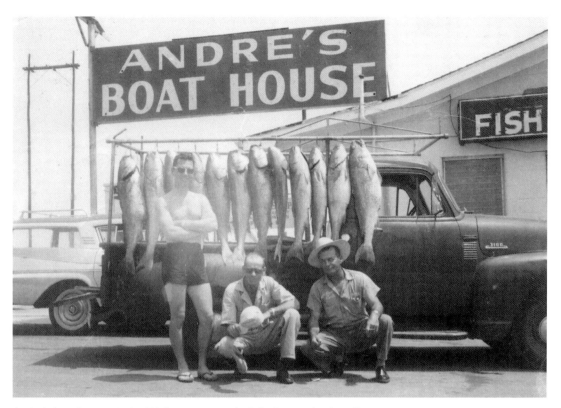

Andre's boat house, 1950s. Ed Stringer is on the left. *Stringer family collection.*

Andre's Restaurant, where Marshwinds is now, ca. 1960s. *Stringer family collection.*

Tackle shop beside Bushy's Restaurant (where Andre's was). This picture was taken in the late-1990s or early 2000. *Courtesy Karen Stringer.*

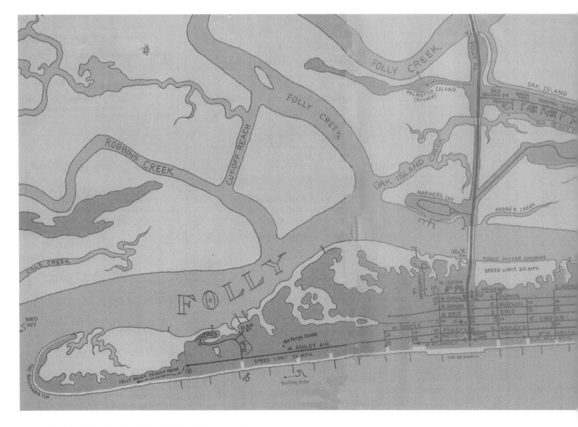

Map of Folly Beach, by R.B. Archambault, 1983.

Bushy's Restaurant, ca. late-1990s. *Courtesy Karen Stringer.*

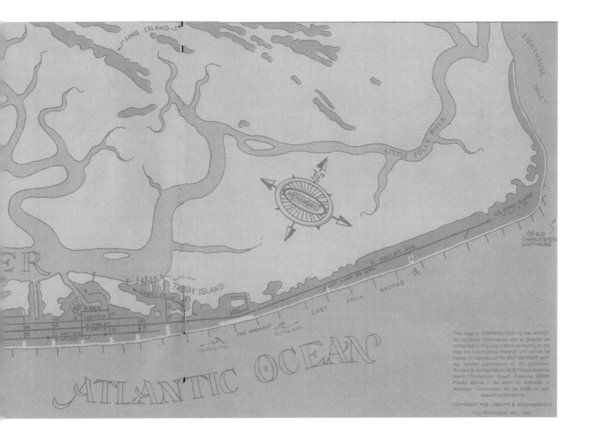

enough to wander the island. It leaned a good seventy-five degrees out to the end where one side was falling into the water. We would dare each other to go across it. Before that, though, I remember all of us, including my Grandmother McDonough, crabbing down there.

Of course, the Village Tackle Shop stood facing Folly Road by the exit from Mariner's Cay. Before it was the Village Tackle Shop, it was just the Tackle Shop or Andre's Tackle Shop. It smelled of beer and shrimp and had a concrete floor with roll-up garage doors. In the spring, they would open all the doors so the entire front would be open. In the winter, we would run inside to wait for the school bus. Amid the tackle and beer were souvenirs, candy and even postcards. To one side was the coffee shop. They had country breakfasts of bacon and eggs, buttery toast and strong coffee. Not for the fainthearted. Doris Snider ran it in the '80s and Amy Stringer Kirshtein worked the grill for a while. It was an amazing place out back, too, with a cinderblock building with three vats in it where they used to keep the live shrimp and lobsters for the seafood restaurant next door. This was originally built in the 1950s as a bomb shelter.

Where Marsh Wind condos are now, Bushy's Seafood Restaurant once stood; before Bushy's it was Sam's and before that it was Andre's Restaurant. There was a mural in the main room of the restaurant, showing a man fishing on "our" island. The painting was done by a fellow just passing through. He was paid in dinners.

Oak Island

In the early 1930s there was only one house on Oak Island. Owned by the Massenbergs, it was later deeded to Sam Harper. This mysterious home was rumored to have been the port of rum-runners. Why? Because of its secret passageways and the hollow brick in the fireplace. Upstairs were false walls that hid various routes into and out of the home. This house still stands on Oak Island, although now it is flanked by other homes.

Cole Island

Longtime resident Betty Sable spoke with Rick Stringer one day and gave him some history of Cole Island. She says that about forty-five to fifty years ago, Papa Sable (Betty's father) owned Cole Island, which is across the Folly River on the west end of Folly. They had a summerhouse there with a smaller wooden house for servants' quarters. The only access to the island was by boat and the Sables would bring their cook and maid with them. They had a windmill on the island that produced electricity.

Papa Sable had a homemade fish trap made from a big wooden box with wire around it. The family had fish twice a day. According to Betty, there had been a Civil War skirmish on that island. She also said that the Spaniards apparently had a fort of some sort on the front of the island and that you could still see it from the air today, circular ruins right on the front of the island on the Atlantic Ocean side. Betty says the original deed from the king of England to Mr. Cole states that if any Spanish treasure is found, the island and treasure would revert to the king. I have not researched this—I like the story just the way it is.

Epilogue

The old pier and Pavilion are gone; now even the steps are gone where once the Newsstand stood; the remains of the Atlantic House are washed by the ocean daily. Where carnival rides and souvenirs were sold now stands the Holiday Inn. Condos now rise where McNally's was. Is it better; is it worse? Who can say?

Buildings and businesses come and go. Thirty years ago no one ever thought the pier would not stretch out into the Atlantic. Then it burned and no one thought it would be rebuilt. Now a new pier reaches into the ocean. Progress is good or bad, depending on your perception. Who can say what Folly will look like in twenty years? Will it be all condos and million-dollar homes? What is an unobstructed view of the ocean worth? How crowded is too crowded?

When I first began working on *Time and Tide* in 1989, I spoke to many people. Those people are now gone. The beach they knew is gone. In the process of preparing the book you hold in your hands, I have talked to many other people. The beach they speak of is different. The only thing we can be sure of is that things will change. Visitors still comment on the laid-back nature of the island. Kids from "up north" still are amazed at the ocean, the floats and gee-gaws in the shops, the taste of boiled peanuts and a cold soda when you've been on the front beach all day. Memory is a powerful thing. Their memories of Folly are as valid as ours and our parents'.

If you travel down the island, onto the side streets where the older homes are, you lose sight of the condos. With a little imagination, you can picture the undergrowth on a few lots, or hear the bands that used to play on the Pavilion, or imagine scanning the Atlantic for a German sub. Yes, we should try to save the small-town feel of Folly Beach; we should not become a mini–Myrtle Beach. Our bohemian atmosphere is what makes us different and Folly has always celebrated that difference.

Folly River at sunset, 1980s.

Folly will survive; she has a rough-and-tumble personality all her own. Not genteel like Charleston, never staid and docile; Folly will somehow always be untamed, a little unconventional, not easily categorized. You can smell it in the salty air on a hot July day. You can hear it when the cicadas chant in the undergrowth along Ashley Avenue. There is a vague quality that makes Folly Beach, South Carolina, unlike any other place in the world. Maybe it *is* the metaphysical center of the universe.

BIBLIOGRAPHY

Beach Erosion at Folly Beach, S.C. Washington, D.C.: Government Printing Office, 1935.

Bierer, Bert W. *Discovering South Carolina*. Columbia: State Printing Co, 1969.

Burton, E. Milby. "Shark Attacks along the South Carolina Coast." *The Scientific Monthly* 40 (March 1935): 279–83.

———. *The Siege of Charleston, 1861–1865*. Columbia: University of South Carolina Press, 1970.

Charleston Evening Post, various editions.

Charleston News and Courier, various editions.

Crane, T.J.L. *Charleston, South Carolina: A Complete Guide—with Maps*. Charleston: privately printed, 1957.

Davis, Nora M. *Military and Naval Operations in South Carolina, 1860—1865*. Columbia: Department of South Carolina Confederate Centennial Celebration, 1959.

Donahue, J. Douglas. Folly Road article, *Charleston News and Courier*, April 13, 1987.

Dupuy, R. Ernest, and Trevor N. Dupuy. *The Compact History of the Revolutionary War*. New York: Hawthorn Books, Inc., 1963.

Folly Beachcomber, various 1960 issues.

Johnson, John. *Defense of Charleston Harbor*. Charleston: Walker, Evans & Cogswell, Co., 1889.

———. *Historic Points of Interest in and around Charleston, S.C.* Confederate Reunion Edition. Charleston: 1896.

Jordan, Laylon Wayne. *History of Storms on the South Carolina Coast*. Charleston: South Carolina Sea Grant Consortium, 1984.

Lennon, Gered. "Field Trip #5, Folly Beach, South Carolina: Tomorrow's Coastal Problems Today," in *A compendium of Field Trips of South Carolina Geology with Emphasis on the Charleston, South Carolina Area*. Compiled by College of Charleston, Department of Geology, in association with the Geological Society of America, for the Southeastern Section Meeting, March 23–24, 2000. South Carolina Department of Natural Resources Geological Survey: 2000.

Longacre, Edward G., ed. "'It Will Be Many a Day before Charleston Falls': Letters of a Union Sergeant on Folly Island, August 1863–April 1864." *South Carolina Historical Magazine*, April 1984:118–34.

Minutes from Folly Beach Commission meetings, various dates.

Plans and Plats AA, Page 177, Secretary of State's Office

Porter, John A. *Personal Recollections 1861–1865*. Edited by James A. Chisman. Clemson, SC: privately printed, 1977.

Purvis, John C. *South Carolina Hurricanes*. Columbia: South Carolina Civil Defense Agency: 1964.

Rhett, Robert Goodwyn. *Charleston: An Epic of Carolina*. Richmond, VA: Garrett & Massic Inc., 1940.

Ripley, Warren. *Battleground, South Carolina in the Revolution*. Charleston, SC: 1921.

Roberts, Nancy. *Ghosts of the Carolinas*. Charlotte, NC: McNally & Loftin, 1967.

Save the Light (newsletter) 2, no. 2 (August 2001).

South Carolina Historical Magazine 81.

South Carolina Historical and Genealogical Magazine, 39 (January 1938).

Simmons, Katherine Drayton. *Stories of Charleston Harbor*. Columbia: The State Company, 1930.

Simms, Mary C. *The New Simms History of South Carolina*. Columbia: The State Company, 1940.

Smythe, Augustine T., et al. *The Carolina Lowcountry, Society for the Preservation of Spirituals*. New York: The MacMillan Company, 1931.

Stephen, Michael F., et al. *Beach Erosion Inventory of Charleston County, S.C., A Preliminary Report*. March 1975.

Stringer, Patrick F. "Observations of Inshore South Carolina Sharks 1967 to 2000" (unpublished report).

INDEX

A

Adams, Fred J. 53, 54
Aguayo, Miquel 61
Aimar, H.A. 45
air raid system 35
Albenesius, Annie Grace 76
Alexander, Herbert 54
American Indians 11, 12
American Revolution 13
Asbell, Emory 75
Ataquin (steamer ferry) 29
Atlantic House 30, 74
 as World War II watchpost 41
 destroyed by Hurricane Hugo 97

B

Ballard, James 59, 61, 75, 80
Baptist Beach House 65
Barber, Pete 46
Barbrey, Helen 54
Battery Gregg. *See* Morris Island during Civil War
Battery Wagner. *See* Morris Island during Civil War
Beach Realty 65, 66
Beach Shore Protection Project 92
Beck, Richard 56
Beckmann, Harry, Jr. 35, 45, 61
Bennett, Manning F. 53, 59, 77
Benson, Cliff 101
Benson, Dicky 68
Benson, Murray 75
Benson, Wallace 54
bird sanctuary 45, 91
Board of Township Commissioners (first) 34
Bowman, Hammond C. 49
Bradham, Elma 101
Bresnihan, Billy 53
bridges 29, 30
 Folly Island Creek Bridge 44
 Folly River Bridge 42, 44
Brown, Janice 68

Brown, Terry 64
Browning, Vivian 56
Bunch, Julian M. 53
Burke, Elmer 46
Burton, Burton 61
Bush, Kenny 68
Bushy's Restaurant 110, 111
Bushy's Seafood Restaurant 112

C

Café Suzanne's 77
Carter, Harry H. 54
Charleston Light. *See* Morris Island Light
Chrysostom, John 69
Chrysostom, Rachel 69
city hall 66
Civic Center 97
Civic Club 61, 62, 63
civic improvements
 garbage collection 37
 paved roads 30, 42, 48
 public safety 44
 streetlights 37
 street signs 42
 telephone exchange initiated 37
 traffic lights 42
 waterworks 42, 46, 47, 48
Civil War 15, 16, 17, 25
 Confederate troops stationed at Morris Island 21
 Keokuk, USS 19, 20
 Union batteries on Folly Island 17, 20
 Union batteries on Folly Island: Swamp Angel 18, 19
 Union troops stationed at Folly 16, 28
Clekis, James 83
coast guard station 39
Cole Island 112
Community Church 63
Conklin, Otis R. 45
Connor-Rooks, Toni 56
Cowsert, Bettie Sue 73
Crawford, D.W. 44
Croffead, George S. 83

D

Davids, William J. 44, 51
Davis, W.A. 101
Douglas, John W. 54

E

early names of Folly Island 13
Ebener's Island. *See* Mariner's Cay
Ecklund, Libby 68
Edwin S. Taylor Pier 88
erosion 30, 53, 91, 92
Estridge, Marlene 53, 56
Estridge, Marvin 54

F

Faith Chapel 63
Flood, Henry 54
Flood, Joe 44
Folly Beach Mounted Patrol 39, 40
Folly Beach Rescue Squad 44, 49
Folly Pier 51, 54, 59, 67, 77, 79, 80, 82, 83, 86, 87
Fred P. Holland Realty 65, 66
Freeman, Ralph 64
Friar, Anita 53

G

Garden Club 63
Gazes, Peter C. 83
Gershwin, George 68
Gilbert, George 30
Goehring, George A. 45, 48
Green Tea Room 63
Greve, Carol 74
Greve, Paul 74

Griffin, Bill 56

H

Hagan, Herman 51
Hall, Tom 56
Hanna, Cheryl 68
Hansbury, Betty Hill 61
Harvey, Lottie 73
Hecker, Captain William 100
Heinsohn, Frank 53
Heinsohn, Frank, Sr. 61
Heyward, DuBose 68
Hill, Josepha Pinckney 61
Hitopoulos, James 44
Holiday Inn 56, 77, 87, 88
Holland, Fred 65
Holland Realty. See Fred P. Holland Realty
Holliday Inn 49
Holmes, Baron, III 45
Hood, Robert 54
Hopkins, Virginia 61
Hudson, Penny Smyrski 61
Hunt, Lee B. 34, 35
hurricanes 31, 93, 94
 Hurricane Hugo 74, 94, 97

I

incorporation 45, 48, 49, 54

J

Jamison, Thomas S. 44
Jastremski, Henry 76
Johnson, Earl R. 45
Johnson, Joanne 61

K

Kachmarsky, John 54
Karow, Lester 79
Kennedy, Regis 54
Keokuk, USS. *See* under Civil War
Kirshtein, Amy Stringer 112
Kline, Marl B. 101
Knox, Vernon 56
Koger, J.W. 51

L

Legare, T. Allen 42
Lempesis, Louis 79, 83
Lennon, Gered 91
Leseman, J.B. 42
Leventis, Andrew P. 53, 83
library 64
Lighthouse Creek 98
Lighthouse Inlet 20, 98
Linville, Bob 56, 66, 97
Little Oak Island 103
Lost Dog Café 73, 74

M

Manos, Pete 74
Mariner's Cay 44, 64, 98, 103, 104, 106, 107, 108
Marks, Thomas 79
Mazo, David 69
McBride, Mildred F. 54
McCarthy, Margaret 65
McCarthy, Michael 65
McCrady, John 46
Mcdonald, Ira 68
McDonough, John F. 34, 37, 39, 53
McDowell, Sims 34
McKevlin, Dennis 49, 54, 55, 73
McKevlin's Surf Shop 59, 73
McLain, Jack 49
McNally's 37, 69, 75
McNally, Grace 75
MeRee, James A. 54
Messervy, Bernie 68
Miss Universe pageant (1960) 51

Morris Island 30, 89, 91, 98
 during Civil War 16, 17, 19, 20, 21, 98
 during Civil War:Battery Gregg 17, 98
 during Civil War:Battery Wagner 17, 21, 22, 23, 24, 98
 during Civil War:Union invasion of 21, 22, 23, 24, 25
 lighthouse 20
Morris Island Inlet. *See* Lighthouse Inlet
Morris Island Light 98, 100
Mr. John's Beach Store 69, 70, 73

N

Nance, Ben 53
Nathans, Jack 49
Newsstand 51, 59, 65, 66
Nicklaus, Kathy 64

O

Oak Island 112
Oceans Sports. *See* Ocean Surf
Ocean Front Hotel 79, 81
Ocean Plaza 82, 83
Ocean Surf 71, 73
Olney, Lottie 64
Our Lady of Good Counsel 63, 64
Owens, Anna 61
Owens, Mickey 68

P

Pappas, Dr. Anthony 45
Pavilion 51, 54, 59, 77, 79, 80, 86
Peeples, Ben 54, 55
Perry, Bill 73
Pete's Hot Dogs 74
Pierce, Pat 66
Planet Follywood 59, 60, 65, 76
post office 31, 54, 59, 61

R

Regan, William 53
Rivers, L. Mendel 34
Robinson, Ed 86
Robinson, Steve 56

S

Sandbar Restaurant 56, 64, 65
Sand Dollar Social Club 73
Sanitary Restaurant 72, 73
Save the Light Foundation 100, 103
Schwartz, Lester 68
Schwartz, Paul 68
Sealey, Dorothy 54, 64
Secker, Mrs. William R. 35
Seres, A. 34
Shiadaressi, Ted 77
Shuler, Henry E. 44
Shute's Folly 12
Smith, Clarence 49
Smith, Fabian B. 48
Smoak, Edward M. 54, 67
Smoak, Mary Sue 68
Snider, Doris 112
Statewide Retreat Policy 92
Steel, Mrs. John 63
Steele, George 67, 68
Strange, Eddie 68
Strickland, Marshall 44
Stringer, Jackie 54
Stringer, Joy 61
Stringer, Karen 56, 74
Stringer, Lester E. 45, 48, 49, 51, 81
Stringer, Rick 54, 55, 67
Stuart, James 45, 48, 51
Suggs, L.D. 59, 61

surfing 55
 controversy 55
 ordinance 55
Swamp Angel. *See* under Civil War

T

Tamsberg, Charles T. 68
Taylor, Eddie 74
Thevenot, Andre 104
Thomas, John 68
Thomas, John B. 53
Tinken, Sue 75
Tittle, George 56
Toulouse, Marcel 61
Troneck's Midget Market 49
Turner, Dorothy 64
turtles 91

V

Valenti, Richard 54
Village Tackle Shop 76, 86, 112
volunteer fire department 44, 51

W

Walker, Larry 67, 68
water tower 48
Weatherford, Richard 73
Whitcomb, Rex 54
Wienges, Clifton 59
Wienges, Kitty 59, 65, 66
Wienges, Tommy 54, 59, 65, 66, 79
Wilbanks, Florence 69
Wilbanks, H.W. 69
Wilbanks, John F. 53, 54
Wilder, Edward E. 54
Winningham, Curtis H. 48
Wood, June 80, 104
World War II 37, 39, 65

Z

Zick, Vicki 56

About the Author

Gretchen Stringer-Robinson grew up on Little Oak Island, now known as Mariner's Cay. As a child on the beach, she roamed the islands and listened to the stories so many of the residents wanted to share. Her connection with Folly goes back generations: her grandparents came to the island in the '30s and her grandfather was the first township commissioner. Her mother was a child on Folly when the roads were not paved and water had to be brought in. Gretchen's parents met while her father was stationed on Folly during World War II.

Gretchen and her husband met on Folly and the island is still home to many friends and family. For Gretchen, Folly Beach will always be a place for peaceful contemplation by the ocean, crabbing in the marsh or chatting with friends over a cup of coffee at the local diner.

Visit us at
www.historypress.net